We do not go into these green woods and crystal waters to rough it, we go to smooth it. We get it rough enough at home, in towns and cities, in shops, offices, stores, banks.

Nessmuk
Woodcraft
1884

Green Woods & Crystal Waters

THE AMERICAN LANDSCAPE TRADITION

JOHN ARTHUR

The Philbrook Museum of Art : Tulsa

Published by
The Philbrook Museum of Art
2727 South Rockford Road
Tulsa, Oklahoma 74114

Distributed in association with
The University of Washington Press
P.O. Box 50096
Seattle, Washington 98145-5096

ISBN 0-86659-021-8

**Library of Congress
Cataloging-in-Publication Data**

Arthur, John, 1939–
 Green woods & crystal waters : the
American landscape tradition / John Arthur.
 p. cm.
 Catalog of an exhibition held at the Philbrook
Museum of Art, Tulsa, Okla., Sept. 12–Nov. 7,
1999, the John and Mabel Ringling Museum of
Art, Sarasota, Fla., Jan. 14–Mar. 19, 2000, and
the Davenport Museum of Art, Iowa, Apr. 16–
June 24, 2000.
 Includes bibliographical references and index.
 ISBN 0-86659-021-8
 1. Landscape painting, American Exhibitions.
2. Lanscape painting—20th century—United
States Exhibitions. I. Philbrook Museum of Art.
II. John and Mabel Ringling Museum of Art.
III. Davenport Museum of Art (Davenport, Iowa)
IV. Title. V. Title: Green woods and crystal
waters
 ND1351.6 .A7797 1999
 758' .173'09737473—dc21
 99–38336
 CIP

This catalogue was published in conjunction with
the exhibition **Green Woods & Crystal Waters:
The American Landscape Tradition,** an exhibi-
tion organized by The Philbrook Museum of Art.
The exhibition and publication were made pos-
sible by the support of members of Philbrook's
Contemporary Consortium—Chandler-Frates &
Reitz, Meinig Family Foundation, Margaret and
Jack Neely, Ruth K. Nelson and Tom Murphy, and
Rita E. and Donald H. Newman; CITGO
Petroleum Corporation; the Mervin Bovaird
Foundation; the John Steele Zink Foundation;
Anchor Paint; the Paul L. and Helen I. Sisk
Charitable Trust; and the Oklahoma Arts Council.

Guest curator: John Arthur
Coordinating curator: Chris Kallenberger
Publication coordinator: Carl Brune
Editors: Mandy Heller and Sally Dennison
Copy editor: Hazel Rowena Mills
Designer: Carl Brune

Printed and bound by Snoeck-Ducaju & Zoon,
Ghent, Belgium

Contents

Acknowledgments

The portrayal of the American landscape is as complex as our nation itself. *Green Woods and Crystal Waters: The American Landscape Tradition* brings that story of landscape painting up to our present day. It builds on the legacy of such nineteenth-century masters as Thomas Moran and Frederic Church, who captured the grandeur of the American continent. The interpretations of the landscape over the last two centuries expressed the imaginary as well as the real. In this survey of the last fifty years of the twentieth century, the eighty-nine artists included in this exhibition demonstrate both a nostalgic fascination with the past and a keen observation of contemporary reality. Their styles and themes reflect their time and place, and are as richly varied as the geographic diversity of America.

This exhibition and publication would not be possible without the artists themselves, first and foremost, and the numerous museums, private collectors, and galleries which so generously loaned these remarkable works. To all, we are deeply grateful. I am indebted to Christine K. Kallenberger, director of exhibitions and collections for Philbrook, who has overseen all aspects of this project from its inception, and to our guest curator, John Arthur. Without John's expert eye and insightful observations about the artists and the context of landscape painting in

America, the original idea would not have reached fruition. Like any major national loan show, its organization has required extraordinary professionalism and talent. Special thanks go to David Gabel, registrar, for his capable management of loan arrangements and transport of the works; to Carl Brune, head graphic designer, and his able assistant, Jesse Candy, for their sensitivity to the design of the catalogue and their ability to produce miracles of beauty under enormous pressure; and to Kimberly Cooper, an intern, and Dana Carlisle Kletchka, coordinator of docent and interpretive programs, for their astute accuracy in proofreading the manuscript. Finally, our board of trustees must be commended for its ongoing support of our special exhibitions program and its encouragement to make scholarly contributions through original exhibitions that explore new ideas.

Green Woods and Crystal Waters has been made possible by the generous support of the underwriters for the project. Without their commitment and enthusiasm, this exhibition and publication could not have occurred. Our heartfelt thanks go to the members of the Contemporary Consortium— Chandler-Frates & Reitz, Meinig Family Foundation, Margaret and Jack Neely, Rita H. and Donald H. Newman, and Ruth K.

Nelson and Tom Murphy; CITGO Petroleum Corporation; the Mervin Bovaird Foundation; the John Steele Zink Foundation; Anchor Paint; the Paul and Helen I. Sisk Charitable Trust; and the Oklahoma Arts Council. We are pleased that this exhibition will also travel to two other institutions, the Davenport Museum of Art, in Davenport, Iowa, and the John and Mabel Ringling Museum of Art, in Sarasota, Florida.

It is our hope that these paintings will inspire, delight, and bring new appreciation for the American landscape tradition and its continuing vitality into the next century.

Marcia Y. Manhart
Executive Director
The Philbrook Museum of Art

Prologue

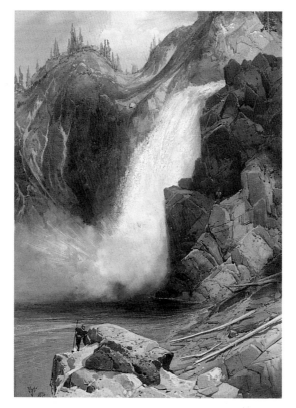

Figure no. 1
Thomas Moran American, 1837–1926
Upper Falls Yellowstone 1874
Watercolor on paper, 14 x 9¾ inches
The Philbrook Museum of Art, Tulsa, Oklahoma,
gift of Mr. and Mrs. John Zink

"Moved across the country & reached the 2nd Canyon of the Madison & camped in it. It is a grand canyon."

Thomas Moran, August 11, 1871[1]

"Mr. Thomas Moran has delivered to Congress his picture of the Yellowstone Valley, the instance being the first in our history where a work of art that is neither heroic art or historical art has been chosen for national purchase. The painting obtained from Mr. Moran is a landscape; or to do more justice to its scope and multiplication of points of sight, a diorama; or, to rise with the occasion in qualifying a picture that explains the marvels of geological formation and natural chemistry, it is a chart of physical geography."

The Nation, September 5, 1872[2]

On a rainy day in the winter of 1974 I left the Visual Arts office in the Department of the Interior to visit the National Collection of Fine Arts (now the National Museum of American Art). At the time, I was working on the Bicentennial exhibition *America 1976*, and for several months I had inquired about Thomas Moran's great paintings, *Grand Canyon of the Yellowstone* (1872) and *Chasm of the Colorado* (1873–74). Both were listed as belonging to Interior, but no one in the agency could tell me where they were located. Finally, a friend at the National Endowment for the Arts and Humanities said that another large version, *The Grand Canyon of the Yellowstone* (1893–1901), was in the National Collection. I spent a leisurely afternoon wondering through its deserted galleries, but I could not find the monumental canvas. Finally I asked a guard if he knew where the Moran was hanging. He led me to an area used for a coatroom and there was the spectacular *Grand Canyon* on the back wall behind rows of the racks.

A century earlier, in 1872 to be exact, the *Grand Canyon of the Yellowstone* and a group of Moran's watercolors (figure no. 1, p. 8) and drawings had played a major role in obtaining the legislation for establishing our national park system. The painting was based on Moran's plein air studies and William Henry Jackson's photographs of Yellowstone made on a government sponsored geological and exploratory expedition led by F.V. Hayden.

Moran's *Grand Canyon* was the first landscape to hang in the Capitol, and in the summer of 1872 it was purchased for $10,000 through a special appropriation by Congress. This and the other Moran paintings were, in the context of our natural environment, politics, and culture, of great import.

We rolled the racks aside so that I could get an unobstructed view of the monumental canvas. It was disturbing to see that a painting of such historic and esthetic import had fallen into such low regard. As I studied the painting, I remembered that in spite of the extravagant holdings of the Gilcrease Museum, I had never seen a work by Thomas Cole, Frederic Church, Albert Bierstadt, Moran, or any other nineteenth-century American landscape painter in art history, nor was there serious discussion of their work in the studio classes.

Looking back, the effects of the cultural and esthetic biases demonstrated by our leading cultural, educational, and political institutions during the sixties and seventies could be best described as a cultural lobotomy. For example, those were the years that many significant works of architecture, such as H.H. Richardson's John Hay/ Henry Adams House, Louis Sullivan's Chicago Stock Exchange, and Frank Lloyd Wright's Larkin Building, were demolished in the name of urban renewal.

During this same period Barbara Novak had

argued with great tenacity that nineteenth-century American art could provide a significant area of study for her doctorate at Harvard. The committee disagreed, and eventually she finished her thesis at Columbia University. That study led to Novak's landmark book, *Nature and Culture*, published in 1980. At the time she was writing that key study, not a single woman artist or American landscape painting was included in H.W. Janson's *History of Art: A Survey of the Major Visual Arts from the Dawn of History to the Present Day*. It was the most widely used art history text in universities throughout the country. Also, many major museums de-accessioned their holdings of nineteenth-century American landscapes on the grounds that they were of little esthetic merit.

While I was working on *America 1976*, an exhibition of seventy-eight works created especially for the project by forty-four contemporary realists and figurative painters, most of the museum professionals and established artists chosen by the National Endowment to advise the G.S.A.'s Art in Architecture Program in the selection of painters and sculptors for commissions argued that beyond Roy Lichtenstein, Andy Warhol, and James Rosenquist there were no noteworthy figurative artists capable of handling a major mural or sculpture project.

Concurrently, the Museum of Modern Art was organizing a Bicentennial exhibition called *The Natural Paradise*. The curator, Kynaston McShine, described it as an "opportunity to examine the true nature of the American achievement and to make some judgments about its overall contribution to art history. This book and the exhibition it accompanies explore a particular theme: the Romantic tradition in American art."[3] Although the exhibit included the earlier work of Edward Hopper, Charles Burchfield, Edwin Dickinson, Georgia O'Keeffe, Andrew Wyeth, Maxfield Parrish, and Milton Avery, it gave no indication that they were still productive in the fifties and sixties. But the thesis of the catalogue and its essays argued that the true heirs of American landscape painting, especially in its romantic ramifications, were the Abstract Expressionists. It made a wild leap from Thomas Cole, Frederic Church, Thomas Moran, George Inness, Martin Johnson Heade, and twentieth-century artists such as Marsden Hartley, Burchfield, Wyeth, and Avery to the paintings of Mark Rothko, Jackson Pollock, Clyfford Still, Barnett Newman, and Arshile Gorky. McShine argued,

> For the twentieth-century artist nature was no longer an end but an intellectual means. Given his identification of self with nature and his perception of the developments of twentieth-century European art and philosophy, it was inevitable that he should eventually state his work in abstract means.[4]

With the assistance of three leading scholars of nineteenth-century painting, Barbara Novak, Robert Rosenblum, and John Wilmerding, and by distorting, omitting, and twisting both esthetic attitudes and historical facts, McShine shoehorned American landscape painting into MoMA's extremely biased and self-serving version of twentieth-century art history. Unfortunately, the situation has not significantly changed over the last two decades.

This exhibition has a dual purpose. First, it is intended to clarify the numerous alignments of these contemporary artists with our own landscape tradition. Secondly, through the theme of landscape painting it will illustrate the diversity and extravagance of American realism and figuration in the last half of the twentieth century. However, I readily acknowledge that for every painter or graphic artist included, three or four others of equal merit have been omitted. Such is the problem with all exhibitions, catalogues, and books. Nevertheless, it will serve as a good indication of the landscape painting that is being produced in America at the turn of the twenty-first century.

Last, there is an underlying aspect of the exhibition that should not go unstated. I believe that the visual arts are an interpretive and poetic means of expression, rather than being philosophical, primarily descriptive, or empir-ical in character, and I would argue that all art is most meaningful when it refers to the human situation in a coherent, well-crafted, communicative form.

Above all, I would hope that the exhibition will provoke thought and give pleasure.

NOTES

1. Nancy Anderson, et al., *Thomas Moran* (Washington: National Gallery of Art, New Haven: Yale University Press), p. 200.

2. Ibid., p. 205.

3. Kynaston McShine, ed., *The Natural Paradise: Painting in America 1800–1950* (New York: Museum of Modern Art, 1976), p. 7.

4. Ibid., p. 108.

1

Twentieth-Century Progenitors of American Landscape Painting

"There may come or perhaps has come a time when no further progress in truthful representation is possible. There are those who say such a point has been reached and attempt to substitute a more and more simplified calligraphy. This direction is sterile and without hope to those who wish to give painting a richer and more human meaning and a wider scope."

Edward Hopper[1]

When the landscape painter Frederic Edwin Church died on April 7, 1900, Gustave Baumann (1881–1971) was nineteen. He was working in the studio of Curtis Gandy, a commercial artist, and taking night courses at the Art Institute of Chicago. Edward Hopper and Rockwell Kent were enrolled at the New York School of Art, where they studied with William Merritt Chase, Kenneth Hayes Miller, Frank DuMond, and Robert Henri. George Bellows, Gifford Beal, Guy Pène duBois, and Walter Pach were their classmates. Alice Neel, one of the greatest portrait artists of our time, was a little more than two months old.

Shortly after moving his family from Germany to Chicago in 1891, Baumann's father abandoned his wife and four children, and at the age of ten Gustave helped support them. By 1905, he had saved $1,000. He gave half to his mother, and with the remainder sailed for Munich, where he studied for a year at the *Kunstgewerbeschule*. It was a school dedicated to the Arts and Crafts ideals, a fusion of the fine and applied arts and a return to fine craftsmanship in an attempt to reform the shoddy machine production of the Industrial Revolution.

The Arts and Crafts Movement, as expounded by its English originator, the brilliant artisan, writer, revolutionary, and Socialist gadfly William Morris, was both an esthetic and a social cause. It coincided with monumental

shifts in medicine, science, and the economy, and reflected the most progressive thinking of the day. The invention of the elevator had begun to change the shape of our cities, Edison's light bulbs lit them, and the new commuter train systems allowed businessmen to move their families to the suburbs. America was completely mapped, connected from border to border and coast to coast by a maze of railroad tracks, and the shift from agrarianism to industrialization and urbanism was well under way.

The breadth and diversity of our own Arts and Crafts Movement was reflected in Louis Comfort Tiffany's blend of Art Nouveau, Japonisme, and Moorish embellishment in his windows, lamps, and glass; Louis Sullivan's beautifully ornamented skyscrapers and later banks; the low, wide-roofed Prairie School houses of Frank Lloyd Wright; and on the West Coast, the elegant bungalows of Greene and Greene and the earthy cottages of Bernard Maybeck. As in France, the architecture, crafts, and woodblock prints from Japan had a major impact in America, and that influence can be seen in the residences, furniture, applied arts, and much of the visual art of the period. This is clearly evident in the early watercolors by Charles Burchfield, the compositions of Georgia O'Keeffe, and the popularity of the woodcut print during that period. However, Japonisme played a less important role in Austria and Germany. Traces can be

seen in the paintings of Gustav Klimt and the graphic arts and fabric designs by the Wiener Werkstatte master, Kolo Moser. Gustave Baumann learned linocut printmaking during his year in Germany and carried that technique over into his woodcuts rather than employing the Japanese method (inking with watercolor and hand rubbing) practiced by Arthur Wesley Dow, Margaret Jordan Paterson, Georgia O'Keeffe, and other Arts and Crafts artists.

In 1915 Baumann, who had not exhibited beyond the Midwest and was practically unknown outside of Indiana, was one of nine artists to win a gold medal in printmaking at the Panama-Pacific International Exposition in San Francisco. These and other exhibits were installed in the Palace of Fine Arts, designed by Bernard Maybeck. Not only was this pavilion the most popular of the world's fair, the rebuilt rotunda is one of the jewels of Bay Area architecture.

The formal elements, printmaking procedure, and visual character of Baumann's work did not completely coalesce until his move to New Mexico in 1918. After several months in Taos he settled in Santa Fe and remained there until his death in 1971. However, he continued to travel and produced hundreds of gouaches on working trips throughout the West. In addition to the numerous woodcuts depicting the Santa Fe area and the Pecos River Valley,

some of Baumann's finest prints are of Grand Canyon and the redwood trees in California.

He painted small plein air gouaches that served as maquettes for the woodcuts. They were simplified, done to scale, and limited in the number of colors. His use of color, while fairly naturalistic, conveyed both a strong sense of ambience and the specifics of light. Most of the prints were done in editions of 125 impressions. However, rather than running the entire edition, he printed them in sets as they were sold, often making minor modifications to the colors, inks, and image. This is typically indicated in the dotted border surrounding the image, where Baumann used a Roman numeral to show the particular printing set of the edition, followed by the numbers indicating the sequence of print and the edition size.[2]

In the first half of the century Baumann was an extremely influential artist, particularly in the field of woodcut and relief prints. During the thirties, Baumann, John Taylor Arms, and Rockwell Kent were three of the most widely known and highly regarded printmakers in America. Today, Baumann's prints, such as *Winter Corral* (checklist no. 10, p. 23), are again enjoying great popularity and are being enthusiastically collected, due in part to the revival of interest in the American Arts and Crafts Movement.

A disproportionately large number of our most

familiar icons, *Nighthawks*, *Early Sunday Morning*, *New York Movie*, *House by the Railroad*, and *Lighthouse Hill*, for example, were painted by Edward Hopper (1882–1967). His paintings, more than the work of almost any other American artist, are quintessential distillations of the mood and character of our country in the first half of the twentieth century. In fact, the only other images that strike such a resonant and long-lasting note of authenticity are the documentary photographs taken by Walker Evans during the same period.

While almost all of these familiar images depict urban subjects, Hopper was also acknowledged as one of this country's greatest landscape painters. His studio sits near the beach at Truro, Massachusetts, just a few miles from Wellfleet, where Edwin Dickinson painted. Although the two must have encountered each other on the sandy shores of Cape Cod, a subject they shared, there is no mention of it in the literature on either of them. In the fifties and sixties, Hopper completed very few landscapes in oil, concentrating instead on watercolors. Like Edwin Dickinson's plein air paintings, the freshness of Hopper's *Cape Cod Bay* (checklist no. 42, p. 24), which may be his last landscape, stems from his skill as a draftsman and the authoritative and convincing economy of his summation of the subject.

Hopper remarked, "Methods are transient, personality is enduring."[3] In a very similar state-

ment, his old art school classmate Rockwell Kent (1882–1971) wrote, "I think it is real wisdom that now bids me not to try to copy nature in my pictures. Nature itself is beautiful beyond all thought of imitation. So when I work to create a *new* world in my pictures, mixing my spirit with what my eyes have seen and my heart experienced, then at least I attempt that which *can* be done."[4] Through William Merritt Chase and Robert Henri they picked up a procedure that was closer to the academies of Munich than those in Paris, and they were instilled with the impulse for a distinctly individual vision. These are factors that formed American realism in the early part of the century. Both Hopper's early paintings and those by Kent demonstrate this point.

Rockwell Kent is one of the most colorful, contentious, and in many ways one of the most engaging and admirable figures in American art. His stylized, somewhat Art Deco wood engravings are the most widely known facet of his oeuvre, but to think of him only as a book illustrator and engraver is inaccurate, severely limiting, and highly unfortunate. He was also one of the finest American landscape painters in the first half of the century. However, because of his Socialist politics, during his lifetime he was also one of the most controversial figures in American art. He ran for Congress as an American Labor Party candidate in 1948 and during the anti-communist hysteria was summoned to testify at the McCarthy hearings

in 1953, where he took the Fifth Amendment. Like the blacklisted Hollywood writers and actors, Kent's art was widely boycotted, which led him to give eighty-six paintings and hundreds of drawings, prints, and books to the Soviet Union.[5]

Ellen Pearce summed up Kent succinctly:

> If independence, adventurousness, idealism, and virility define the American character, or at least its fond self-image, then Rockwell Kent was one of its finest examples. Described during his life and since . . . as an artist, illustrator, writer, carpenter, architect, adventurer, activist, intellectual, romantic, philanderer, and Communist, Kent combined all with an ardent commitment to beauty, peace, and social justice.[6]

Monhegan Island lies about ten miles off the coast of Maine. It has been visited by many artists since the 1850s, and they continue to be drawn to its dramatic views and diverse topography. Kent first visited this small island at the urging of Robert Henri in 1905. He built a cottage, worked as a carpenter, writer, and fisherman, and remained until 1910. Even though he never again lived on Monhegan, Kent returned regularly for more than fifty years, and many of his finest paintings were done there. The small panel painting *Village at Night* (checklist no. 49, p. 25) depicts the

familiar cluster of buildings silhouetted against the dark ocean and evening sky. It is a quintessential example of Kent's work, for his finest landscapes are always distinguished by their carefully nuanced description of time, topographical character, and ambience.

Among contemporary figurative painters, Edwin Dickinson (1891–1978) is one of the most highly admired American artists of the twentieth century. However, with the exception of *Ruin at Daphne* (1943–53) and the *Fossil Hunters* (1926–28), neither he nor his work has had exposure to a wide audience among the museum-going public. Like Félix Vallotton, Thomas Wilmer Dewing, Giorgio Morandi, and Balthus, he will probably never capture their attention or affection, for the inherent strength of his paintings resides too much in their nuances and subtleties. Where Dickinson spent years on his complex, enigmatic paintings such as *Ruin at Daphne*, *Fossil Hunters*, *The Cello Player*, and *Composition with Still Life*, he was one of the greatest draftsmen of the twentieth century and a major influence as a plein air landscape painter. His 1963 statement, *On My Way of Painting*, is classic of clarity and brevity. The first few sentences address Dickinson's plein air landscapes, and the remainder describes the open-ended evolution of his paintings.

> I am a painter in oil. I have painted many landscapes premier-coup in America and Europe. These I either keep or destroy, but I never work on them more than once. Since 1915 I have painted large figure compositions, working on them from one hundred to four hundred sittings each. No preliminary drawings were made for these compositions, nor were objects to be represented planned before starting. It was always intended, however, that human models, as well as other things, were to be painted. Plans that preceded even the stretching of the canvases included predetermination of the keys, the stretch of values, the color schemes, the number and grouping of the spots, their sizes and their shapes and their variety. When any carefully painted passage was found to be hindering the development of a composition it was removed and in time, a better passage was painted in its place. This practice of eliminating and repainting accounted in part for the many sittings which were felt to be requisite. After working on a composition two years or more, my own development during that period made keeping the painting up to date, as it were, impossible. After years of work on it, a painting could not be quite completely reorganized, nor thrown away, so I often felt forced to stop work on it and to begin another. Very pleasing and exhilarating, too, was always the commencement of a new composition,

unburdened with the dissatisfactions of the old one.[7]

Dickinson studied at the Pratt Institute, National Academy of Design, Art Students League in New York, and with Charles W. Hawthorne in Provincetown, Massachusetts. In turn, he was a highly influential painting teacher at the Art Students League. He served in the U.S. Navy during World War I and traveled extensively in Europe over the years. However, Dickinson always returned to Provincetown or Wellfleet on Cape Cod, where he lived and worked for more than half a century. *Rock, Cape Poge* (checklist no. 24, p. 26) is typical of his vapor-like plein air, *premier coup* ("first-strike," completed in one sitting) paintings. They are among the most revered landscapes in twentieth-century American art, at least for those familiar with them. Through Dickinson, the painterly technique of Hawthorne with its emphasis on form, tone, and value, was refined and passed on to many contemporary painters.

Where Kent was an inveterate adventurer and wanderer, Charles Burchfield, Milton Avery, and Alexandre Hogue relied on their deep empathy, familiarity, and knowledge of their subjects and interpreted the particulars of the regional landscape with great insight and often with uncanny intimacy. Beyond the distinction of their personal vision, the only thing they shared was an aversion to being described as Regionalists. Avery was too much a part of the New York art scene and too distinctly a Modernist to ever be considered a Regionalist.

Grover Cleveland was president when Milton Avery (1893–1965) and Charles Burchfield (1893–1967) were born. That year, in celebration of the four hundredth anniversary of Columbus' discovery of America, the World's Columbian Exposition opened in Chicago, Tiffany perfected his iridescent Favrile glass, and Henry Ford developed his first successful gasoline engine.

No two painters could be more different than Avery and Burchfield. Avery's work is buoyant, charming, and a perpetual delight. His landscapes center on the sensual pleasures provided by the outdoors. Burchfield's watercolors are often brooding and melancholic, and probe the seasonal acts and unseen undercurrents of nature. He suffered from bouts of depression throughout his life.

During 1916 and 1917 Burchfield produced an astonishing array of watercolors that are widely regarded as being among the best American landscape paintings of the first half of the twentieth century. He always referred to 1917 as his "Golden Year." These unique works reflect the influence of Art Nouveau posters, the illustrations of Arthur Rackham, set and costume designs of Léon Bakst, the

mood of the Northern Romantics, and the woodcuts of Hiroshige and Hokusai. But above all, they have no parallel in the American art of that period. At the time, Burchfield had just graduated from the Cleveland School (now the Cleveland Institute) of Art and was twenty-four years old.

Burchfield left Salem, Ohio, for Buffalo, New York in 1921 to take a position with M.H. Birge and Sons as a wallpaper designer. He remained with the firm until 1929. Even though he was a nationally recognized artist by this time, Burchfield was pressured by financial problems most of his life. Unlike the seventies and eighties, the first half of the century did not produce an abundance of millionaire artists.

Burchfield moved with great flexibility from a somber realism to a deeply personal form of iconography, always tailoring the visual means to fit his expressive intents with a total disregard of the disposition of the art world. Often he returned to decades-old watercolors, honing in on the remembered particulars of place, atmosphere, and constitution, and revising and enlarging the images by adding sheets of paper to their perimeters. A summation of Burchfield's attitude is illustrated in *Late Winter Radiance* (checklist no. 18, p. 27) and by his statement, "Look at a tree not only as a design but also as a living, growing object, which has emotions like ourselves."[8]

In 1939 Marsden Hartley exhibited his *Archaic Portraits* at the Hudson Walker Gallery in New York. Although the work was critically hailed, the painter made only $100 from the show. In addition, his dealer managed to trade a painting for a set of dentures, which the sixty-two-year-old artist desperately needed. On his birthday four years earlier, Hartley had destroyed more than a hundred paintings and drawings because he could not afford to pay the storage fees.

One of the paintings in *Archaic Portraits* was a study of Albert Pinkham Ryder, whom Hartley had met and befriended in 1909. That mythical artist's influence can be clearly discerned in Hartley's dark paintings from that period. In 1943 Milton Avery did a remarkable portrait of Marsden Hartley. They were friends, and Hartley was somewhat of a mentor to the younger painter. He is portrayed as being sallow skinned, resigned, and introspective, but an attempt to retain some of his earlier dapperness is indicated by his boutonnière and bright red bow tie. Avery was fifty years old and Hartley was sixty-six.

Avery's wife Sally and daughter March were the subjects of many paintings, and no companion has played a more important role in an artist's career than Sally Avery. They met in Gloucester in 1925 and were married the following year. Sally worked as an illustrator for *Progressive Grocer* and later did ads for

Macy's department store, enabling Avery to spend full time in the studio. His paintings did not begin to sell well until the fifties.

Hilton Kramer, long a champion of Avery, states, "There is scarcely a more refined esthetic intelligence in American art than his. . . . In the deployment of painterly forms, in the whole expressive and logistic enterprise of handling the materials of painting, Avery has been equaled by very few of his contemporaries. . . ."[9]

Milton Avery was a Modernist. His autobiographical paintings reflect a fusion of Fauvism, the sensual palette and reductive forms of Matisse, and the seductive pull of folk art. They center on the minor moments of family life, pleasant summers on the beaches near Gloucester, Massachusetts, or vacations in the lush countryside of Vermont. His canvases and watercolors are always charming and quite often witty, but they are never callow. *Hills and Sunset Sky* (checklist no. 7, p. 28) was painted at the MacDowell Colony in Peterborough, New Hampshire, in the summer of 1964. The masses of form are rendered with stains of lush, sensual color. Assuming a role similar to the one Hartley had played in their relationship, Avery's influence on younger painters such as Mark Rothko, Adolf Gottlieb, and Barnett Newman, whom he met in the late twenties, can be seen most clearly in the reductivism and abstraction of their paintings.

It is most clearly indicated in Rothko's elegant, sonorous color. These painters and their families remained close friends for the rest of their lives.

Mark Rothko's eulogy is a beautiful homage:

> Avery is first a great poet. His is the poetry of sheer loveliness, of sheer beauty. Thanks to him this kind of poetry has been able to survive in our time. . . . For Avery was a great poet-inventor who had invented sonorities never seen nor heard before. From these we have learned much and will learn more for a long time to come.[10]

There are two important keys to an understanding of the landscape paintings of Alexandre Hogue (1898–1994). First, he was instinctively an expressionist and an allegorical artist and, second, he was an impassioned environmentalist with the stern, humorless zeal of a Calvinist minister. His best paintings were based on subjects he experienced firsthand, knew well, and to which he was deeply attached. They range from the early sketch trip paintings of Texas to the mountains around Taos, New Mexico, and his return to the Big Bend area of Texas almost forty years later.

Hogue approached his painting with the skilled efficiency of carpenter or calligrapher, rather than with the painterly eye and sensual

figure no. 2
Alexandre Hogue American, 1898–1994
Erosion No. 2—Mother Earth Laid Bare
1936. Oil on canvas, 40½ x 56¼ inches.
The Philbrook Museum of Art, Tulsa,
Oklahoma, museum purchase

touch of John Singer Sargent, George Bellows, or Charles Demuth. This characteristic was very much a part of the period, for the same can be said of Edward Hopper, Charles Sheeler, Georgia O'Keeffe, and others. Hogue's color was often turgid, and at times his symbols, such as *Grim Reaper* (1932), were corny and overly emphatic. While refusing to acknowledge influences, he felt that an artist must "keep up with the times," which led him into a Constructivist-derived form of non-objective painting that filled the middle years in his seven-decade oeuvre. And yet there were frequent returns to nature, such as the group of angular, calligraphic-like watercolors of sandstone creek beds done on sketching trips with his students to Osage Hills State Park in northeastern Oklahoma. Some of these works are among the best landscapes of his long career.

But Hogue's reputation remains centered on the dust bowl paintings of the thirties. The earliest are based on specific incidents, such as *Avalanche by Wind* and *Road to Rhome*, whereas the later canvases such as *Erosion No. 2—Mother Earth Laid Bare* (figure no. 2) and *Crucified Land* are allegorical. Although it is frequently overlooked, one of the most distinctly personal aspects of these strange landscapes of disaster and despair centers on Hogue's early and acute understanding of the ecological fallacies of over-plowing and over-planting. Farmers literally scraped off the grasses and then depleted the rich topsoil, which greatly increased the damage of the mammoth windstorms that swept across the plains of Kansas, Oklahoma, and Texas. Unlike the Farm Security Administration photographers—Arthur Rothstein, Dorothea Lange, Russell Lee—and other painters and writers of the period, he had little sympathy for their partially self-induced plight. Hogue's paintings are probably the first to consciously and emphatically center on ecological concerns.

In 1970, at the age of seventy-two, Alexandre Hogue began a series of major landscape paintings of the Big Bend country, an untouched geological and topographical wonderland stretching along the sandy shores of the Río Grande and the Mexican border. The canvases are based on a group of small pastels that were begun on site in the summer of 1965 and completed later in his studio. This group of scenes of the desert—its steep mesas, deeply eroded mountains, and vast canyons—makes a remarkable closure to Hogue's long, illustrious career. They depict the majestic beauty of nature's forces untouched by man. *Lava-Capped Mesa, Big Bend* (checklist no. 40, p. 29) illustrates the strange, surreal character and vast expanses of this region, and like his early Taos landscapes, this work and the other Big Bend paintings are rendered with awe, passion, and reverence.

Today Alice Neel (1900–1984) is widely heralded as one of the most remarkable portrait painters of our time, a fact that was acknowledged by almost everyone in the art world for at least two decades before she appeared on the Johnny Carson show. She also was one of the New York art scene's most memorable characters. Neel's insightful wit was irreverent, at times scatological, and frequently quite merciless, and her portraits are devastatingly accurate. Her most tender and sympathetic paintings are of the Puerto Rican, Dominican,

and black children of the neighborhood. *Carmen and Judy*, which depicts Neel's Haitian housekeeper nursing her retarded baby, is one of the finest paintings of a mother and child in contemporary art. When Andy Warhol sat for a portrait, Neel coaxed him into removing his shirt, exposing the long scars and girdle he wore as a result of the surgery after he was shot. She painted Rita Red in drag, David Bourdon in his underwear and red socks, stripped John Perrault and posed him as an odalisque, and painted the art critic Cindy Nemser and her husband in the buff. At the age of eighty Neel painted her self-portrait, brush in hand, and naked as a jaybird.

In a 1983 interview with Patricia Hills, Alice Neel stated:

> I love, fear, and respect people and their struggle, especially in the rat race we live in today, becoming every moment fiercer, attaining epic proportions where murder and annihilation are the end. I am psychologically involved and believe no matter how much we are over-come by our own advertising and commodities, man himself makes the world.[11]

Although Alice Neel's reputation will always rest on her psychologically probing portraits, she occasionally turned her attention to still lifes and landscapes, and those subjects are rendered with the same intensity, incisiveness,

and probity as were her figures and portraits. *Sunset, Riverside Drive* (checklist no. 61, p. 30) illustrates that Neel could easily have been one of our finest landscape painters as well.

Although these artists were born toward the close of the nineteenth century, the body of their work extends well into the second half of the twentieth and is very much a part of the gestalt of our time. Many other major landscape artists such as Charles Sheeler, John Marin, Ralston Crawford, Maxfield Parrish, and Georgia O'Keeffe were also active, productive, and influential figures in contemporary landscape painting.

NOTES

1. Quoted in Lloyd Goodrich, *Edward Hopper* (New York: Harry N. Abrams, n.d.), p. 162.

2. For a thorough discussion of Baumann's procedure, see David Acton, Martin F. Krause, and Madeline Carol Yutseven, *Gustave Baumann: Nearer to Art* (Santa Fe: Museum of New Mexico Press, 1993).

3. Quoted in Richard Todd, *New England Monthly* (May 1988), p. 88.

4. Letter from Rockwell Kent, Monhegan, to HH, quoted in *Rockwell Kent on Monhegan* (Monhegan, Maine: Monhegan Museum, 1998), p. 17.

5. This body of work is illustrated in Scott R. Ferris and Ellen Pearce, *Rockwell Kent's Forgotten Landscapes* (Camden, Maine: Down East Books, 1998).

6. Ibid., p. 8.

7. Quoted in Eric Protter, ed., *Painters on Painting* (New York: Universal Library, 1963), p. 223.

8. Quoted in Nancy Weekly, ed., *Life Cycles: The Charles E. Burchfield Collection* (Buffalo, New York: Burchfield-Penny Center, Buffalo State College), p. 267.

9. Hilton Kramer, *Milton Avery Paintings: 1930–1960* (New York: Thomas Yoseloff, 1962), p. 11.

10. Quoted in Adelyn D. Breeskin, *Milton Avery* (Washington, D.C.: National Collection of Fine Arts, Smithsonian Institution, 1969), unpaginated.

11. Quoted in Patricia Hills, *Alice Neel* (New York: Harry N. Abrams, 1983) p. 185. Hills' interviews with Neel, which form the core of this book, provide a remarkable account of this artist.

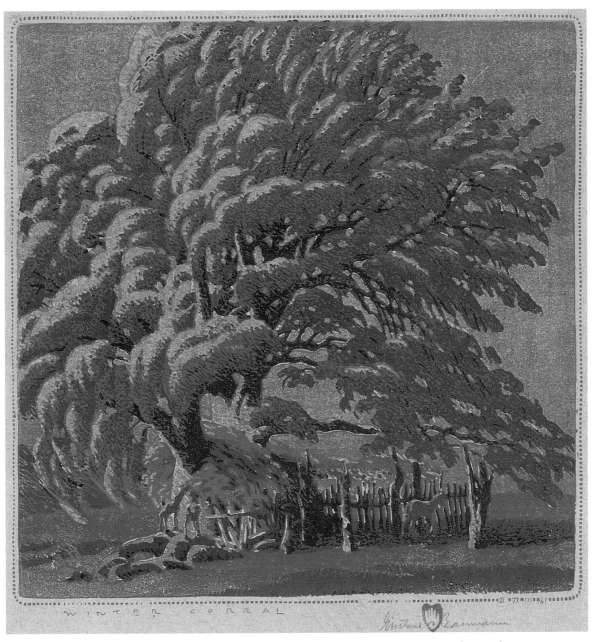

Gustave Baumann 1891–1971 **Winter Corral** 1950–61 woodcut 12¾ x 12¾ inches
Lent by Ann Baumann
checklist no. 10

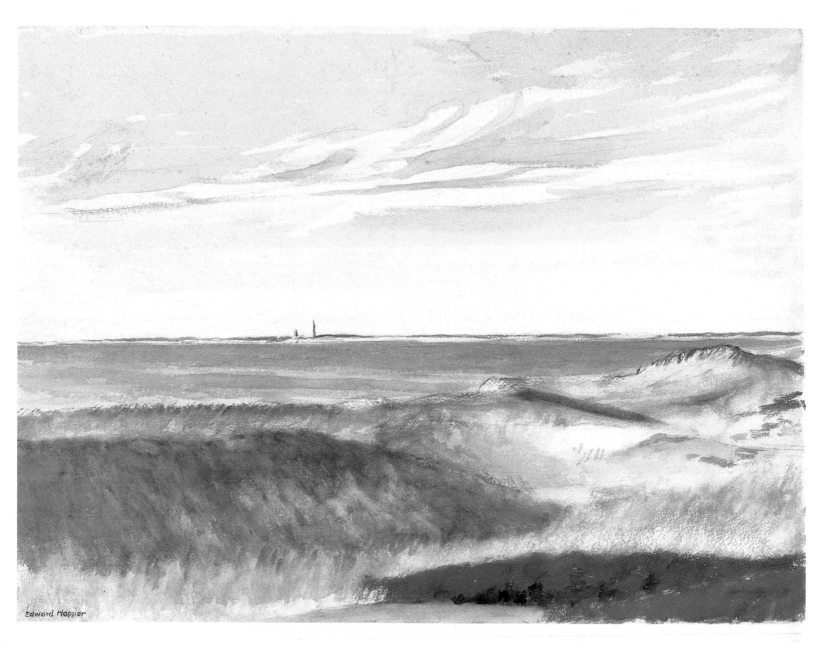

Edward Hopper 1882–1967 **Cape Cod Bay** 1965 watercolor on paper 22⅛ x 29⅞ inches
Whitney Museum of American Art, New York, Josephine N. Hopper Bequest
checklist no. 42

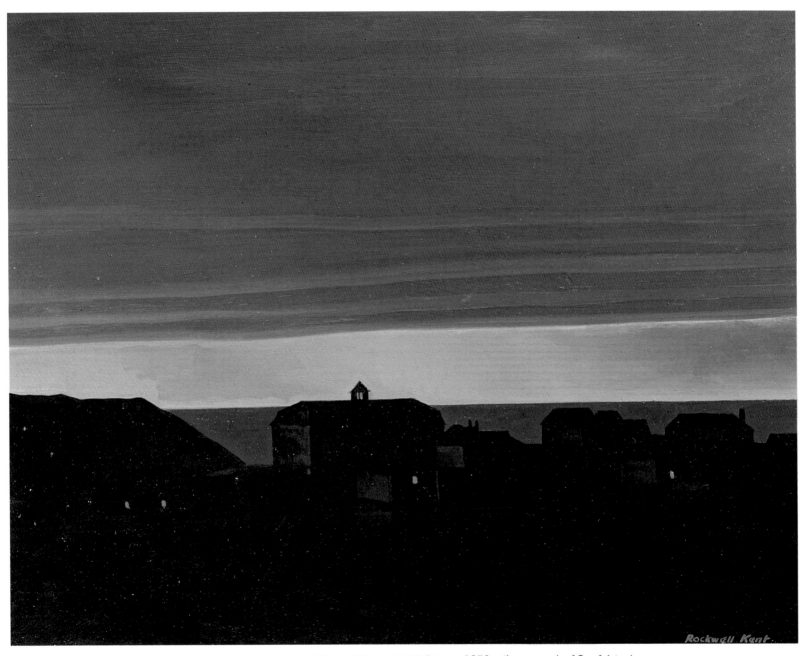

Rockwell Kent 1882–1971 **Village at Night** c. 1950 oil on panel 12 x 16 inches
Collection of Remak Ramsay, New York
checklist no. 49

Edwin Dickinson 1891–1978 **Rock, Cape Poge** 1950 oil on canvas 11½ x 14¼ inches
Collection of Mr. and Mrs. Daniel W. Dietrich II, Chester Springs, Pennsylvania
checklist no. 24

Charles Burchfield 1893–1967 **Late Winter Radiance** 1961–62 watercolor on paper 44 x 26½ inches
The Butler Institute of American Art, Youngstown, Ohio, museum purchase, 1962

checklist no. 18

Milton Avery 1893–1965 **Hills and Sunset Sky** 1964 oil on canvas 40 x 48 inches

Milton Avery Trust, courtesy of Knoedler & Company, New York

checklist no. 7

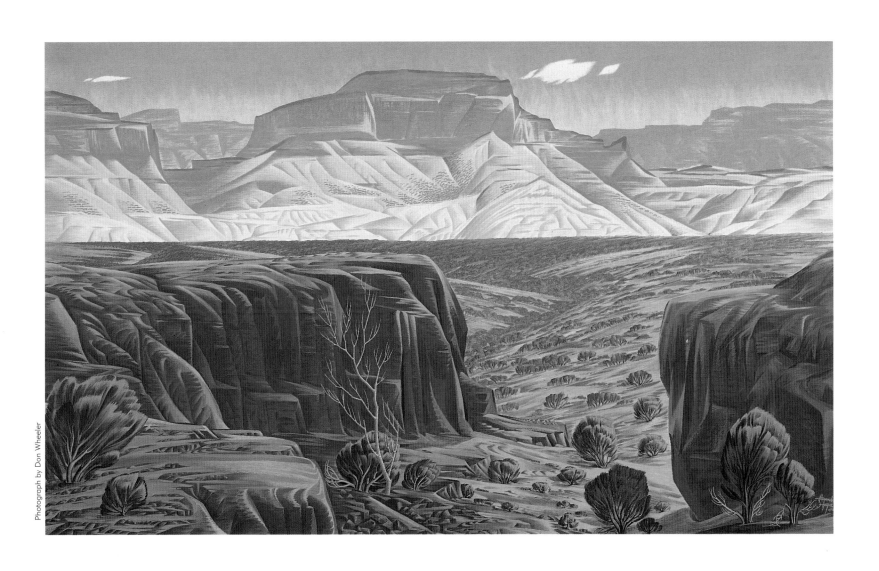

Alexandre Hogue 1898–1994 **Lava-Capped Mesa, Big Bend** 1976 oil on canvas 34 x 56 inches
University of Tulsa
checklist no. 40

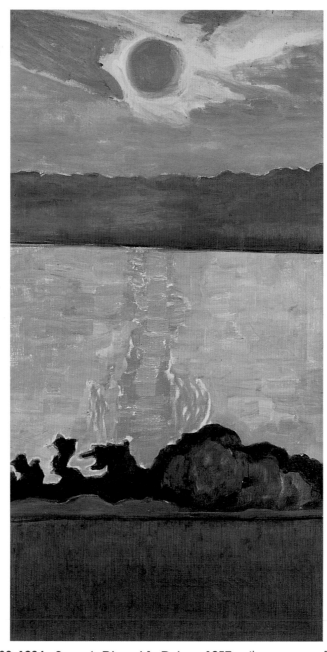

Alice Neel 1900–1984 **Sunset, Riverside Drive** 1957 oil on canvas 50 x 26 inches

Estate of Alice Neel, courtesy of Robert Miller Gallery, New York

checklist no. 61

2 Realism and Figuration in the Decades of Abstraction

"Experience, and experience alone, tells me that representational painting and sculpture have rarely achieved more than minor quality in recent years, and that the major quality gravitates more and more toward the nonrepresentational."

Clement Greenberg
1954[1]

"I would just as soon not comment on the arts of today other than to say that I think any comment is futile; when a decadence sets in, and really gets rolling, there is nothing that can stop it; it must run its course before a renaissance can begin.

"I can't possibly see what a course in design would do for an artist if he did not also have academic training in life drawing, still life, and composition—in fact, the renaissance in the arts I mentioned will be impossible unless these subjects are restored to the artist's training. Otherwise we will continue on the barren road of decoration that most artists are now traveling. Thank God there are a few individualists who refuse to conform."

Charles Burchfield
1959[2]

"He [Clement Greenberg] thought the critic's role to be that of an especially competent interpreter of the Will of History.…

"To say that you cannot paint the figure today, is like an architectural critic saying that you must not use ornament, or as if a literary critic proscribed reminiscence. In each case the critical remark is less descriptive of what is going on than it is a call for a following—a slogan demanding allegiance. In this case criticism is so much influenced by politics that it imitates the technique of a totalitarian party on the way to power."

Fairfield Porter
1962[3]

In 1953 Matisse's beautiful ceramic tile mural *Apollo*, which was based on a theme from Ovid's *Metamorphosis*, was completed. After working on *Ruin at Daphne* for a decade, Edwin Dickinson finally accepted it as being finished that year. Balthus had painted his enigmatic, sexually charged *Golden Days* five years earlier. Willem de Kooning's ferocious, razor-teethed *Women* were sending shock waves through the art world and Jackson

Pollock was again edging toward figuration with paintings such as *Portrait and a Dream*. In 1954, perhaps as an homage to Matisse who had died earlier that year, Picasso painted a series of fifteen variations on Delacroix's *Women of Algiers*. It was precisely at this time, with full knowledge of such achievements, that Clement Greenberg declared "representational painting and sculpture have rarely achieved more than minor quality in recent years."

Fairfield Porter was one of the few art critics to argue against Greenberg's narrow-minded Formalist esthetics, and fortunately he had the foundation in art history and philosophy and the independent turn of mind required to meet the challenge. In 1955 he wrote a scathing response to Greenberg's *Partisan Review* article on "American-type" painting in which Greenberg had again questioned the viability of figurative painting. At that time Porter was widely known as a critic and reviewer rather than as a painter. He was forty-eight years old and had known Greenberg for sixteen years.

Fairfield Porter was born in Winnetka, Illinois, in 1907. He was the fourth of five children and the brother of Eliot Porter, the great naturalist and photographer. Porter's father, an architect of independent means, bought an island off the coast of Maine where he built a summer home which Fairfield inherited. Many of his best-known paintings and watercolors, including *View of Barred Islands* (checklist no.

69, p. 44), were done there. Other works depict his family and friends, the comfortable rooms, and the surroundings of the Porter home in Southampton, Long Island.

After completing an art history degree at Harvard in 1928, Porter enrolled in figure drawing classes at the Art Students League. His instructors were Boardman Robinson and Thomas Hart Benton. A decade later, a major exhibition of paintings by Pierre Bonnard and Edouard Vuillard had a profound and lasting effect on his painting.

In 1939 Porter moved to Peekskill, New York, where he met Willem de Kooning, the photographer Rudy Burkhardt, and others through the dance critic Edwin Denby. They remained close, supportive friends from that time until Porter's death in 1975.

In 1951 Porter began reviewing for *ARTnews*. He wrote perceptively and positively about the first exhibitions of Alex Katz, Jane Freilicher, Alfred Leslie, Wolf Kahn, Jasper Johns, Roy Lichtenstein, and many other emerging artists.[4]

That same year Willem and Elaine de Kooning, Larry Rivers, Jane Freilicher, and several others recommended him to the Tibor de Nagy Gallery. Porter was highly respected for the sharpness of his intellect, the breadth of his knowledge, and above all, he was a painter's

painter. Although he did not stray from naturalism, Porter was a beautiful colorist, and the clarity of his perception was enhanced by the painterly sensuality of his oils and watercolors. *View of Barred Islands* is a beautiful distillation of the clear skies and crisp air that typify the northern Maine coast. Like all of his landscapes, still lifes, and portraits, it corresponds very closely to the look of things. Porter's paintings are either directly observed or based on watercolors and small plein air studies.

Today it is difficult to grasp the enormous, and quite frequently, the dictatorial power wielded by Clement Greenberg and Harold Rosenberg in the fifties and sixties. Their esthetic positions, which provided little room for figuration, were widely accepted as doctrine by the leading art periodicals, in most of the major art schools and universities, and throughout the museum world. Now, fifty years later, the reverberations of their criticism lingers on.

From the first time they met in 1939, Porter remained resolute in his opposition to Greenberg's Formalist esthetics.

> One reason I never became an abstract painter is that I used to see Clement Greenberg regularly and we always argued, we always disagreed. Everything one of us said, the other would say no. He told me I was very conceited. I thought my opinions were as good as his

or better. I introduced him to de Kooning (Greenberg was publicizing Pollock at that time), and he said to de Kooning (who was painting the women), 'You can't paint that way nowadays.' And I thought: who the hell is he to say that? He said, 'You can't paint figuratively today.' And I thought: if that's what he says, I think I will do just exactly what he says I can't do. I might have become an abstract painter if it weren't for that.[5]

The painters Jane Freilicher, Jane Wilson, Paul Georges, Rackstraw Downes, and Neil Welliver and poets such as John Ashbery, James Schuyler, Kenneth Koch, Frank O'Hara, and Ted Berrigan, as well as younger artists such as Joe Brainard were a part of Porter's circle. Among his many portraits, there are very astute and sympathetic paintings of both Freilicher and Wilson. By comparison, Alice Neel's sardonic portrait of Wilson, her husband John Gruen and daughter Julia provides an interesting and provocative foil.

Freilicher majored in art at Brooklyn College and later took classes with Nell Blaine. Blaine had studied with Hans Hofmann and encouraged her to enroll in his school. In 1947 her friend Larry Rivers, who was also painting with Blaine, decided to attend with her. Other students in the class at that time were Paul Georges, Richard Stankiewicz, Paul Resika, Wolf Kahn, Robert Goodnough, and Leatrice

Rose. Like Freilicher and Rivers, many of them are now major figurative painters. Freilicher stated ". . . it wasn't just I who veered away from abstraction. But Hofmann wasn't restrictive in that sense. In fact, he always tried to make connections with the past."[6]

Freilicher gradually moved from an expressionist form of figuration with traces of Bonnard to the airy, painterly realism that has characterized her work for the past three decades. Although she has painted many still lifes and studio interiors with views of the Long Island marshes and dunes beyond, she is best known for her landscapes. As the title indicates, *Cherry Blossoms Painted Outdoors* (checklist no. 31, p. 45) is a plein air study. It is a perfect summation of the gentle light and fresh growth of spring.

Nell Blaine began to draw and paint at a precocious age. She studied at the Richmond School of Art (now Virginia Commonwealth University), and moved to New York in 1942 to study with Hans Hofmann. Under his influence she began painting abstractly. Blaine was disciplined and prolific, and she traveled extensively. By the mid-fifties, her paintings were a loose, gestural form of figuration, which was described by several critics as "abstract impressionism." After traveling and working in Mexico, her color became richer and more brightly keyed.

In 1959, while living in Greece, Blaine was stricken with polio. After eight months in the hospital she learned to paint with her left hand, but the remainder of her life was spent in a wheelchair. She settled into a routine, broken by travel, of wintering in New York and spending the remainder of the year in Gloucester, Massachusetts. Many of her paintings and watercolors depict the picturesque view of the harbor and her garden. In addition, she painted many still lifes and opulent bouquets. Even though it is a view of the Connecticut countryside, *First Lyme Landscape* (checklist no. 15, p. 46) is typical of her mature work. It is spontaneous, colorful, and ebullient, and offers a clear indication of why Nell Blaine's paintings and watercolors are admired by many painters, critics, and collectors, and by the public.

The pensive *Storm Light* by Jane Wilson (checklist no. 85, p. 47) is based on the transience of weather, but her interpretation is more of a reminiscence of such momentary conditions. The specifics of the landscape or Long Island coastal waters dissolve, shifting the emphasis to the sky, and Wilson's lush, shimmering skies are more about conjuring moods than describing the specifics of meteorology.

Luc Sante has perhaps written the most poetic description of her paintings. "Together Jane Wilson and the sky have made an encyclo-pedia of moods and textures and marks and palettes, delineating the immense multiple personality we collectively name weather. The sky, which has no memory of its own, is tremendously fortunate to have her as its portraitist, its analyst, its biographer."[7]

Without question, Wolf Kahn is one of the most popular landscape artists in America. His paintings and pastels of the Vermont countryside are lushly colored and seductively vibrant. He is highly disciplined and prolific, and the quality of his work is extremely consistent.

At the age of twelve Kahn escaped Nazi Germany in a transport of children to England two weeks before the outbreak of World War II. A year later he joined his father in the United States. In New York, he studied at the High School of Music and Art, took classes with Stuart Davis and Hans Jelinek at the New School for Social Research, and then in the late forties spent two years in Hofmann's school. Kahn had his first solo exhibit more than forty years ago, and since then he has had numerous shows throughout the country and abroad.

Although his paintings have always centered on color, Kahn moved from an agitated, expressionistic form of figuration in the fifties to the hushed shadows, glowing light, and ambiguous, remembered forms of the landscape in the sixties. By the early seventies he

had settled into the diaphanous, hazy layers of lush chromatics that are the hallmark of his work, which is clearly illustrated in *Rhapsody in Yellow* (checklist no. 47, p. 48). There is no system to his use of color; it is intuitive, sensual, and open-ended. He has described his painting as "doing Rothko over from Nature," and like so many of his generation of realists and figurative painters, Kahn's work reflects the influence of the Abstract Expressionists.

Martica Sawin has described Wolf Kahn's painting procedure, which begins as plein air observations that are completed later from memory:

> In Vermont between June and September he starts as many canvases as possible directly from nature. He brings these back to New York, to the environment in which he thinks his paintings grow best. Where he claims to "see nature more clearly, undistracted by trees and skies." There in the lair he has created for himself during thirty years of occupancy the idea takes over and merges with formal concept. However, despite the studio finishing process, the sense of time and place is vividly present in the final work, perhaps sharpened in recollection.[8]

Philip Pearlstein, Alex Katz, Lennart Anderson, and Neil Welliver are internationally acknowledged as central figures in contemporary American realism. Each of them has redefined a major aspect of figurative painting and brought it into our time.

Pearlstein came to national prominence in the early sixties with his paintings and wash drawings of nudes. There was no attempt to romanticize, embellish, dramatize, or give them narrative or allegorical trappings. From the beginning, they were exactly what they appeared to be—models posed in the studio. Over the last three decades his compositions have become more elaborate and colorful. They are now loaded with a wide assortment of props and are rendered with greater finesse, but his paintings remain, just as they were thirty years ago, unblinking views of hired models clinically lit with a triangulation of lights.

After his discharge from the army in 1946, Pearlstein returned to Pittsburgh and resumed his studies at Carnegie Institute of Technology (now Carnegie-Mellon University). Upon graduation he moved to New York, where he worked with the well-known graphic designer Ladislov Sutner. Before his marriage, Pearlstein shared an apartment with Andy Warhol, a close friend and fellow classmate from the institute. While continuing his work with Sutner, he entered the graduate program at the Institute of Fine Arts in art history.

Pearlstein has stated, "We were the generation

of artists who built on the lessons of the art of painters like de Kooning, Kline, etc."[9] This central point is continually overlooked, for Pearlstein and other realists, such as Alex Katz, Paul Georges, Alfred Leslie, Wayne Thiebaud, and Nell Blaine, reflect one of the many facets of contemporary art—from the paintings of Jasper Johns, Andy Warhol, Robert Rauschenberg, Kenneth Noland, Robert Mangold, and others—that shares the monumental influence of the Abstract Expressionists as a common inheritance.

Pearlstein's move from abstraction to realism was first marked by a Soutine-like painting of *Superman* (1952) that predates Warhol and Lichtenstein's variations on the comics by almost a decade. Following that canvas was a group of directly observed sepia watercolors of rocks, tangled roots, Italian cliffs, and Roman ruins that served as studies for larger, more vigorously rendered canvases. These early wash drawings and paintings form the bridge between his abstractions and figure paintings. While not as well known as the nudes, Pearlstein's paintings, watercolors, and prints of geological landscape formations such as *Grand Canyon* (checklist no. 67, p. 49) and others depicting ancient ruins throughout the world reflect his long interest in art history and archaeology. They have been an ongoing and important aspect of Pearlstein's oeuvre from 1953 to the present. Just as his figure compositions are done entirely from life, the large

watercolor and oil landscapes are painted completely on site.

The classical painter of this generation of realists is Lennart Anderson. He grew up in Detroit, took Saturday afternoon painting classes at the School of Arts and Crafts, and later studied at Cass Technical High School. He graduated with a scholarship to the Art Institute of Chicago. In 1946 he was one of three students enrolling from high school; all the others were GIs returning from the war. His remarkable facilities as a painter and draftsman attracted attention immediately. Given the esthetic climate of the Art Institute—Monster School painters such as Leon Golub, Ted Halkin, and Cosmo Compoli were fellow students—Anderson strove at that time for the expressionism of Kokoschka, Soutine, and Rouault. From Chicago, he entered the graduate program at Cranbrook. Growing tired of expressionism, he finished the year painting *premier coup* portraits of his classmates for $15 each, and by the end of the semester he had saved enough money for his first trip to New York.

While in Manhattan, Anderson saw the auction catalogues for the contents of Degas' studio. This seemingly minor incident had a lasting impact.

In an interview with Mark Strand, Anderson stated, "Hundreds of drawings, pastels, and paintings were reproduced. I was very excited

by this austere man, whose work reflected such pain, almost disgust, as well as passion for his goal. His heroic effort to maintain the nude as a noble subject for art inspired me, and still does."[10]

When he returned to Cranbrook in the fall of 1951 Anderson began the first of his street scenes, which he painted over as soon as it was completed. *Accident (Street Scene)* 1955–1958, which covers that first foray into narrative painting, is one of his best known works. He described the impulse behind the enigmatic subject: "I wanted to paint an emotional subject (Manet after all had painted a suicide) without an expressionist approach, to paint as if I were only an observer."[11]

Anderson has brought the classicism of David, Puvis de Chavannes, and Degas into our time and circumstance. Like Edwin Dickinson, he has worked on large, allegorical canvases such as his *Idyll I* and *II* for many years and these compositions have undergone numerous alterations. In regard to his masterly skill as a draftsman, painter, and composer, he has frequently been compared to Degas. However, in addition to the major narrative and allegorical paintings, Anderson is noted for his beautiful still lifes, nudes, and landscapes. For many years he has painted small plein air studies such as *Footbridge at Topsham, Maine* (checklist no. 6, p. 50), that are typically completed in one sitting.

The bold, poster-like images of Alex Katz are a fusion of Abstract Expressionism, contemporary realism, the reductive imagery of Matisse, and commercial advertising. They share the crispness and the bland, emotional detachment of Pop Art, have the immediacy and impact of a billboard, and are often painted at the same scale. For almost half a century, his subjects have centered around his wife Ada and son Vincent, the minor moments of their private life, friends and acquaintances from the art world and literary circles, the Paul Taylor Dance Company, and pleasant summers in Maine.

Katz was born in New York in 1927 and in almost every way, he is the epitome of the New York artist. He was educated at Cooper Union Art School and studied at the Skowhegan School of Painting and Sculpture in Maine.

Sanford Schwartz has very astutely summarized Katz's paintings:

> . . . we know that he is really after the beautiful, but that he wants to get there indirectly. He wants to surprise us, to make us grasp it.

> Though we also sense that the pretty does represent the beautiful to him, and that to see the world through his eyes is to see everything in a transformed way. This is possibly why his paintings often

have the haloed becalmed quality of primitive and naïve art. . . . He is an ironical, indirect master. His passionateness is there but buried. He is a visionary of the shallow glossy surface of life, something that before him, one might have thought it was impossible to be visionary about.[12]

The woods, pond, and familiar yellow cottage in Katz's paintings depict his summer home and its surroundings. The small plein air panel, *Untitled (Shore Scene)* (checklist no. 48, p. 51) is one of the earliest of the small collages and paintings of Maine. Although these landscapes and portraits were more painterly, the crisp editing, rich color and light, and freshness of the work from the period serve as an indicator of the course Katz's paintings would take.

Neil Welliver lives year round in the Maine woods. Although he is only a few miles from Katz, his work and his attitude are drastically different. Welliver has been a deeply committed environmentalist for decades, and it is a concern that is imbedded in his way of life rather than being limited to annual contributions to a few well-known causes. He owns more than a thousand acres of forests, heats his home and studio with wood, generates his own electricity, and is an organic gardener. It is an industrious, rugged, and extremely self-sufficient lifestyle.

Welliver attended the Philadelphia Museum

and received his MFA from the Yale University School of Art, where he studied with Josef Albers. After graduating he taught at Yale and later was the director of graduate painting at the University of Pennsylvania. He is bright, literate, tough-minded, and independent.

His paintings either depict the landscape surrounding his home or the rugged Allegash of northern Maine. All begin as small plein air canvases which depict virtually every aspect of these untrammeled woods in all its seasons, from the early pinks and mauves of the peat boggs, the fern-filled undergrowth of summer, and the extravagantly colored fall to the icy streams and snow-covered forests of that region's harsh, inhospitable winters. These serve as the basis of his large canvases, which are produced in the studio. *Winter Stream* (checklist no. 84, p. 52) was drawn and painted from a small outdoor study which was done at a time of the year when the streams are beginning to thaw but the extreme cold congeals the oil paint into a gummy consistency.

The poet Mark Strand has written:

Welliver's work forces us to confront a world of particulars. In his paintings, there is no blurring of distinctions, no mild presentation of an undifferentiated otherness, nothing seems approximate or reductive. There are no congenial

appeals to our ignorance, no cloudy approximations of this or that. His paintings manifest, instead, an inclination to be as various as the world they portray. Welliver does not make one thing of many—he makes one complicated thing of another complicated thing. His search for equivalence is an act of home. His vision of plenitude is restorative. It does not soothe; it excites. Looking at his work, we feel that it is the result of an almost fiendish descriptive power, that the thousands of snowflakes, leaves, branches, shadows, tree trunks, ripples, rocks, cracks, grassblades, are in fact a vision of power endlessly restored, an allegory of the infinite.[13]

In order to bring Andrew Wyeth into a meaningful contextual focus, it must be kept in mind that he was born in 1917. He is ten years younger than the late Fairfield Porter, a decade older than Alex Katz, and roughly the same age as the West Coast painters Theophilus Brown, Wayne Thiebaud, and Paul Wonner. Unlike other artists of this generation, he acknowledges no debt to Abstract Expressionism. In fact, he has kept a distance from the art world throughout his entire career, which now covers more than six decades. Although he is neither as great as his legions of swooning admirers claim or as bad as his distractors make him out to be, Wyeth is certainly one of the major landscape painters of

our time. Without question he is the most popular and revered artist in America. Ironically, while Wyeth is extremely well known here and in Japan, he is almost unknown in Europe.

Wyeth's watercolors and temperas superficially appear to be extremely realistic, but the watercolors are quite painterly and spontaneous and his temperas are tightly keyed constructions. In fact, they more closely approximate the chromatic range, richness, and visual beauty of the long-exposure chiaroscuro photographs of the Barbizon Forest by Eugène Cuvelier and the sharply etched, tactile extravagance of Carlton Watkins' large albumen prints of Yosemite. Where they appeared to be facilely photographic several decades ago, the sleight of hand airbrushed paintings by Photorealists such as Chuck Close and Ben Schonzeit dispelled that notion, as do the landscapes of James Winn, William Beckman, and Catherine Murphy.

Basically, Wyeth is a descendent of the Golden Age of Illustration, which marked a high point in American art at the turn of the century when little distinction was made between commercial and fine art. More specifically, he evolves from the close tutelage of his father, N.C. Wyeth, one of the greatest figures of the Golden Age.

Wyeth's paintings are stylistically akin to those of English Victorian watercolorists such as

Margaret Waterfield and Samuel Elgood, for example, or those by the art critic John Ruskin. But in various remarks, Wyeth seems to set himself outside art history. For example, he has stated, "I don't have much feeling for the past. My feeling for history is not connected with dates: it is the way the landscape looks in the moonlight."[14]

A 1943 statement is one of the most lucid Andrew Wyeth has made about his work.

> My inherent desire to draw and paint was whipped into action by many youthful adventures in my father's studio, where at the age of fourteen I started a long period of instruction. This training consisted of incessant drilling in drawing and construction from cast, from life, and from landscape, "and so" my father often said, "to understand nature objectively and thus be soundly prepared for later excursion into subjective moods and the high spirit of personal and emotional expression."

> My aim is to escape the medium with which I work. To leave no residue of technical mannerisms to stand between my expression and the observer. To seek freedom through significant form and design rather than through the diversion of so-called free and accidental brush handling. In short, to dissolve into clear air all impediments that might interrupt the flow of pure enjoyment. Not to exhibit craft, but rather to submerge it, and make it rightfully the handmaiden of beauty, power, and emotional content.[15]

Brambles (checklist no. 88, p. 53) verifies Wyeth's attitude to a certain extent. It is almost Oriental in composition and subject. However, the watercolor belies his stated notion in regard to his facility with watercolor and tempera. Rather than a diversion, the mellifluent expressiveness of his painterly descriptions, particularly as it conjoins with his poetics, illustrates the fact that he is above all a conjuror of moods rather than a descriptive, naturalistic painter.[16]

Despite Wyeth's earth-toned palette and the lack of topographical flamboyance in his landscapes, his descriptive skills recall the painterly confidence displayed in the plein air oil studies of Frederic Church and the Yosemite watercolors of Thomas Moran. Wyeth's is an art that is both inside and outside the American landscape tradition.

The careers of these painters serve to illustrate the breadth and diversity of American figurative art after the war. Importantly, the connecting thread that runs through their work and that of their peers throughout the country is the long-standing tradition of perceptual painting.

NOTES

1. Clement Greenberg, *Art and Culture: Critical Essays* (Boston: Beacon Press, 1961), p. 135.

2. Quoted in Protter, *Painters on Painting*, p. 227.

3. Fairfield Porter, *Fairfield Porter: Art in Its Own Terms*, p. 70.

4. Ibid, p. 30.

5. Quoted in an interview by Paul Cummings, *Fairfield Porter: Realist Painter in an Age of Abstraction* (Boston: Museum of Fine Arts, 1982), p. 56.

6. Robert Doty, ed., *Jane Freilicher Paintings* (New York: Taplinger Publishing Co., 1986), p. 48.

7. Luc Sante, *Jane Wilson* (New York: Fischbach Gallery, 1997), unpaginated.

8. Martica Sawin, *Wolf Kahn: Landscape Painter* (New York: Taplinger Publishing Co., 1981), p. 33. This is an excellent introduction to Kahn's work and procedure.

9. Philip Pearlstein, "A Realist Artist in an Abstract World" reprinted in *Philip Pearlstein: A Retrospective* (Milwaukee Art Museum; New York: Alpine Fine Arts Collection, Ltd., 1983), p. 13.

10. Mark Strand, ed., *Art of the Real* (New York: Clarkson N. Potter, Inc.), p. 140.

11. Ibid., p. 140.

12. Sanford Schwartz, *Alex Katz Drawings: 1944–1981* (New York: Marlborough Gallery, 1982), p. 6.

13. Mark Strand, foreword, and Ruth Fine, introduction, *Neil Welliver Prints: 1973–1995* (Camden, Maine: Down East Books, 1996), p. 1.

14. Beth Venn and Adam D. Weinberg, with a contribution by Michael Kammen, *Unknown Terrain: The Landscapes of Andrew Wyeth* (New York: Whitney Museum of American Art and Harry N. Abrams, Inc., 1998), p. 200.

15. Quoted in Protter, p. 252.

16. It is informative and enlightening to visually compare Wyeth's *Brambles* with the watercolors of Joseph Raffael, Carolyn Brady, and Patricia Tobacco Forrester.

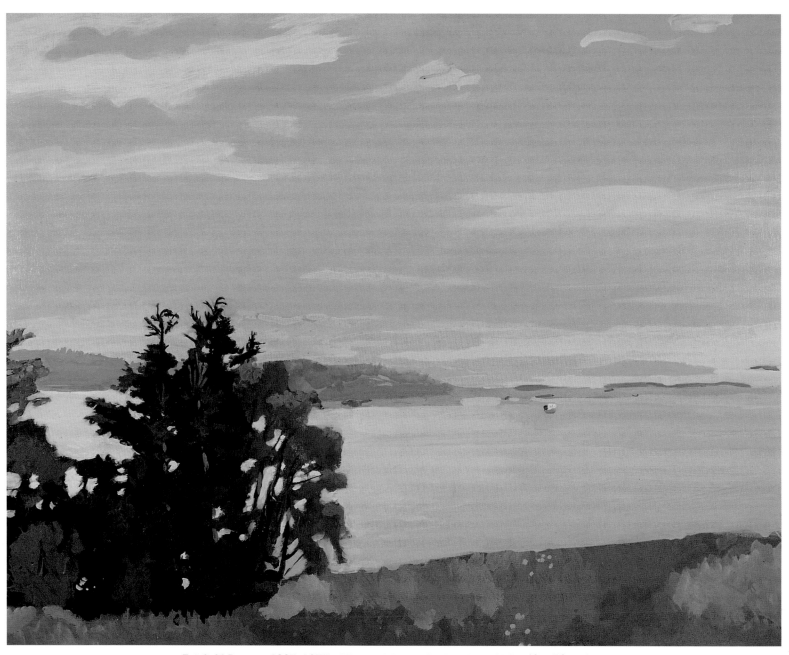

Fairfield Porter 1907–1975 **View of Barred Islands** 1970 40 x 50 inches
Rose Art Museum, Brandeis University, Waltham, Massachusetts, Herbert W. Plimpton Collection
checklist no. 69

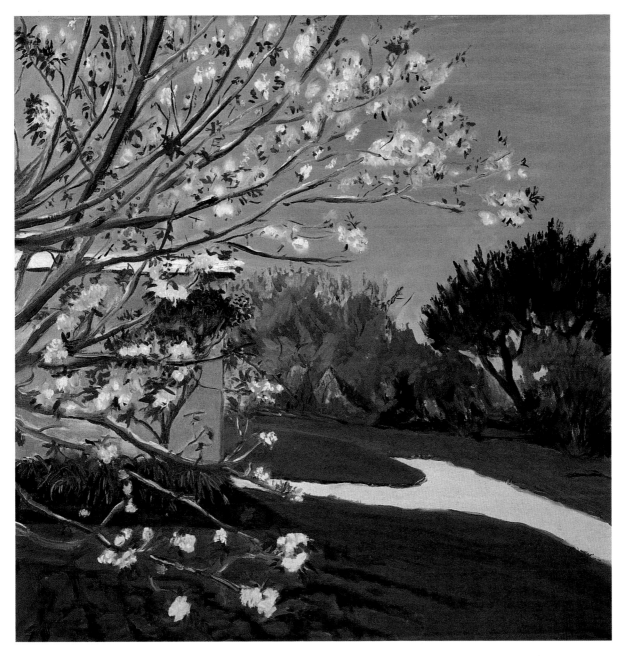

Jane Freilicher b. 1924 **Cherry Blossoms Painted Outdoors** 1977 oil on canvas 36 x 36 inches

The Currier Gallery of Art, Manchester, New Hampshire

checklist no. 31

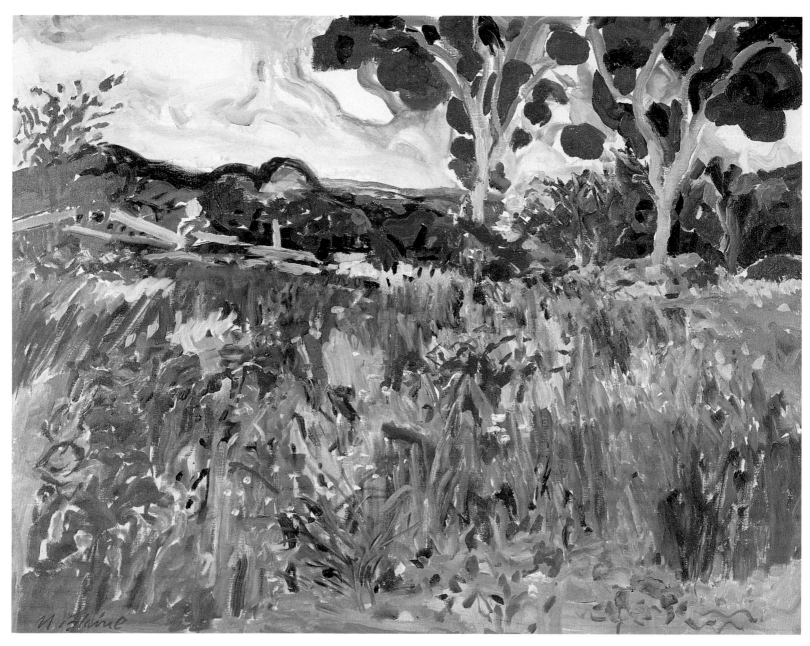

Nell Blaine 1922–1996 **First Lyme Landscape** 1973 oil on canvas 27½ x 36¼
The Springfield Art Museum, Springfield, Missouri
checklist no. 15

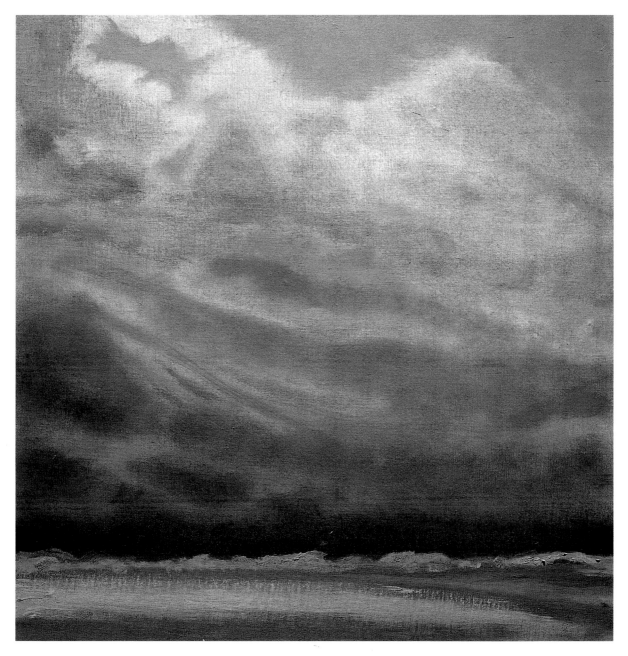

Jane Wilson b. 1924 **Storm Light** 1993 oil on linen 24 x 24 inches
Courtesy of D. C. Moore Gallery, New York
checklist no. 85

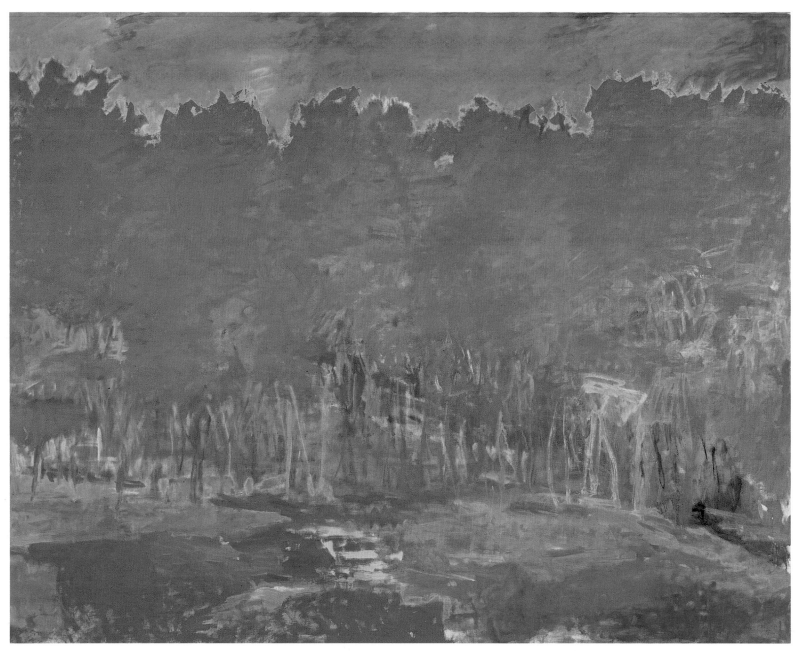

Wolf Kahn b. 1944 **Rhapsody in Yellow** 1997 oil on canvas 70 X 90 inches
Courtesy of Beadleston Gallery, New York
checklist no. 47

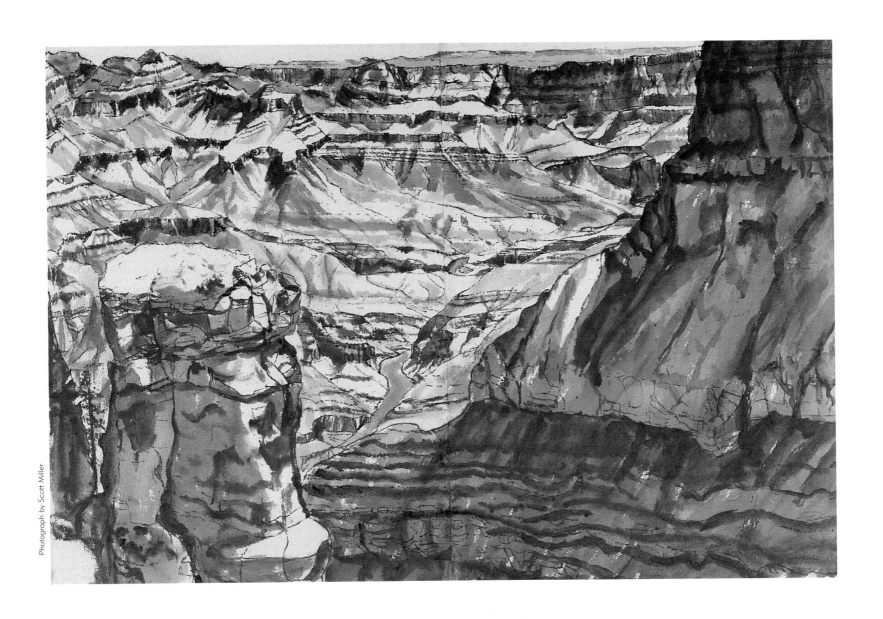

Philip Pearlstein b. 1924 **Grand Canyon—Moran Point** 1975 sepia wash 29 x 43½ inches

Collection of William G. Pearlstein and Miranda S. Schiller

checklist no. 67

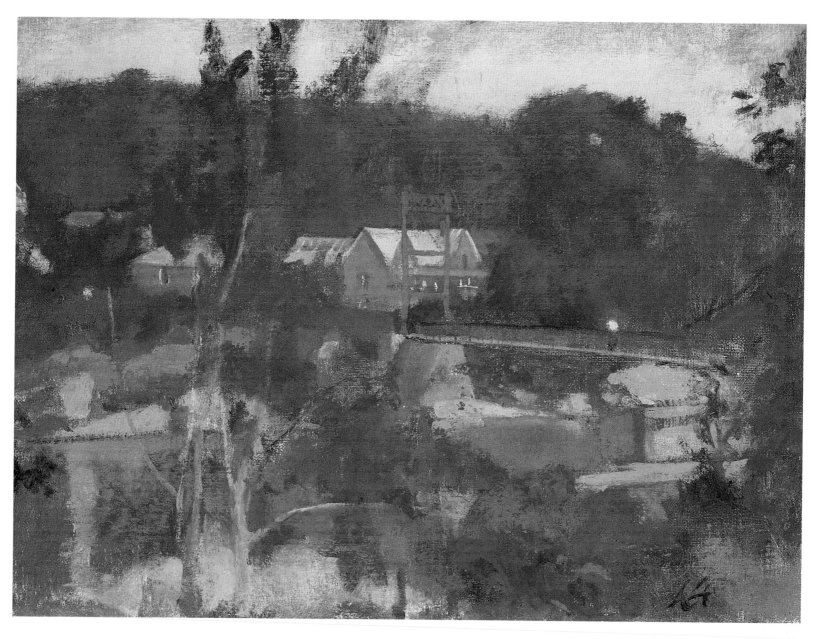

Lennart Anderson b. 1928 **Footbridge at Topsham, Maine** 1983 oil on canvas $10^{5}/_{8}$ x 15 inches
Courtesy of Salander-O'Reilly Galleries, New York
checklist no. 6

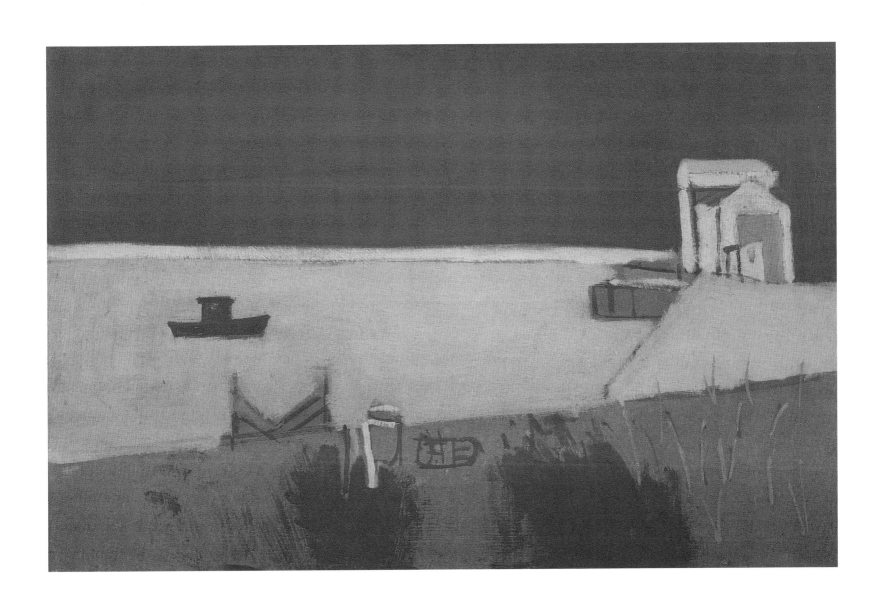

Alex Katz b. 1927 **Untitled (Shore Scene)** 1956 oil on board 16 x 24 inches
Courtesy of Robert Miller Gallery, New York
checklist no. 48

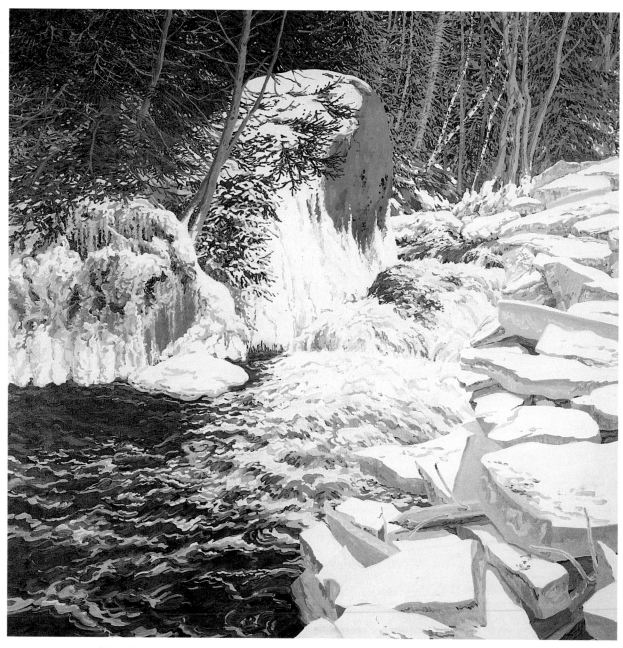

Neil Welliver b. 1929 **Winter Stream** 1976 oil on canvas 96 x 96 inches
Smith College Museum of Art, Northampton, Massachusetts, gift of Mrs. Leonard S. Mudge
in memory of Polly Mudge Welliver, class of 1960

checklist no. 84

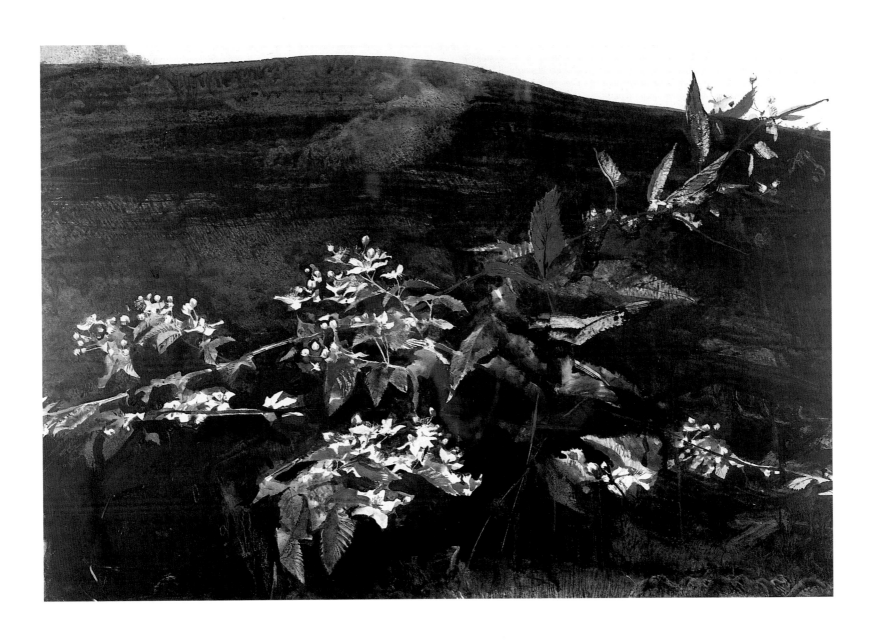

Andrew Wyeth b. 1917 **Brambles** n.d. watercolor on paper 21¼ x 29⅛ inches
Collection of Marylouise Tandy Cowan, Boothbay Harbor, Maine
checklist no. 88

3 The Contemporary Practice of Plein Air Painting

"There is a style that consists in not making a big fuss about things. 'One may as well begin with. . . .' E.M. Forster begins with in *Howard's End*; and in a wonderful poem James Schuyler writes that he wants 'merely to say, to see and say, things as they are.' The artist may present himself as diffident or offhand, while working his intensity into stating the facts in a way that doesn't draw attention to itself.

Rackstraw Downes[1]

Without doubt the most obsessively observed and astutely rendered contemporary plein air canvases are those by Rackstraw Downes and Catherine Murphy. Both shun the picturesque in their drawings and paintings. Murphy leans toward the more commonplace subjects and minor moments of suburban life. Downes, who is one of the most thoughtful and articulate artists in America, is noted for his unvarnished urban and rural views. Among his many literary accomplishments, he edited and wrote the introduction to *Art in Its Own Terms*, a selection of Fairfield Porter's reviews and criticism, which includes his well-known clash with Clement Greenberg. It is an essential book for anyone with a serious interest in the art of our time.

Today, Rackstraw Downes divides his time between New York and Texas, which is as distant a geographic and cultural polarity as can be imagined. Over the years, he has painted some of the most unpromising and frequently downright scruffy views of Maine, New Jersey, and Manhattan. More recently, Downes has focused on the parched, arid southwestern fields and has rendered those scenes, such as *Rainwater Ditch and Six Culvert Bridge, Texas City, Texas* (checklist no. 26, p. 60), with the same attentiveness, intelligence, and painterly care given to the glorious views of Venice and London by Canaletto in the eighteenth century. To quote Hayden Herrera, "Our attention is held also by the vastness of his spaces and the richness of incident that fills them." Downes

not only elevates our interest in these overlooked themes of panoramic views of freeways, housing projects, and Texas fields, he also imbues them with a deep and unerring sense of authenticity.

For the past two decades Catherine Murphy's paintings have centered on her home and studio. Like Downes, she never allows her virtuosity to overwhelm her directly observed subjects. Basically she is a genre painter, and in that realm she is a remarkable recorder of the inauspicious moments of suburban life: a family gathering in the yard; an entrance hall, cellar stairs, and kitchen; a bedside still life; or neighbors at the front door. In addition, she has done remarkable portraits, self-portraits, and backyard landscapes. Most of Murphy's paintings are distinguished by her subtle but extremely complex manipulation of interior and exterior space. Her landscapes are inauspicious views from the window or yard of her suburban home. The heightened realism of *Driveway onto East Dorsey Lane* (checklist no. 60, p. 61), with its midday shadows, weeds, greenery, and elaborate foreground pattern of chards and stone nods, simultaneously toward the formal characteristics of abstract composition and the carefully honed, fastidious empiricism of direct observation.

Like many of the European and American eighteenth- and nineteenth-century plein air painters, Marjorie Portnow is an inveterate traveler. She has recently settled in a small town in New York state, but continues to accommodate her practice of painting outdoors throughout the country by accepting various short-term teaching and house sitting stints. As in the work of Downes and Murphy (indeed, it is perhaps the dominant characteristic of all accomplished plein air painting from the eighteenth century to our time), the understated, self-assured rendering of atmosphere, topography, flora, and space, as seen in Portnow's California landscape, *Camino Cielo II, Santa Barbara (Heaven's Doorway)* (checklist no. 70, p. 62), is unerringly convincing.

The Boston painter John Moore is best known for his large, complex urban views, still lifes, and interior-exterior compositions. Many of these multilayered works are pieced together from a variety of source material and are ultimately more fictive than literal. However, his small *Summer Evening* (checklist no. 57, p. 63) is a directly observed painting of a neighbor's home adjacent to the Moores' summer cottage in Maine.

The landscapes of Altoon Sultan, William Beckman, Peter Poskas, Ann Lofquist, and Keith Jacobshagen center on agrarianism and rural life. With the exception of her egg temperas, all of Altoon Sultan's meticulously observed views, such as *Plastic Wrapped Bales, Barnet, Vermont* (checklist no. 76, p. 64), are painted on site. They clearly reveal that her

carefully honed skills of observation are coupled with a solid understanding of the gritty aspects of contemporary farming.

William Beckman's *Parshall's Barn* (checklist no. 12, p. 65) differs from the previous works in that it is a studio composition based on meticulous pastels and drawings. These are done on site, using the centuries-old device of a stringed grid for framing and placement. The crystalline lucidity of this image with its vast space and sky is reminiscent of seventeenth-century Dutch paintings. Like many of Beckman's figure paintings, this landscape has undergone major alterations. At one point the entire foreground was reworked, which has drastically altered the spatial character of the composition. An earlier version can be seen in the exhibition catalogue *Realism/Photorealism*, published by The Philbrook Museum of Art in 1980.

Like *Parshall's Barn*, the studio compositions by Keith Jacobshagen, Ann Lofquist, and Peter Poskas are derived from small plein air works. Ann Lofquist's studies and Keith Jacobshagen's *Tractor Road-edge of Salt Valley* (checklist no. 45, p. 66) differ from the directly observed paintings by Downes and the other previously mentioned artists in that they are completed in one sitting. Jacobshagen's ambient plein air views of Nebraska are painted on stained paper. They are filled with particulars and transient incidents, such as a distant brushfire, flocking crows, or en-croaching weather, and quite often notations and autobiographical musings are written across the lower margins of these works. His large canvases are based on these small outdoor paintings.

Ann Lofquist and Peter Poskas are both New England artists. Lofquist lives in Maine, and most of her small, *premier coup* panels are painted in the Brunswick area. She also occasionally works in western Massachusetts. These fresh, rapidly executed panels are extremely astute observations of momentary light, color, and mood. They serve as notations for her large, open-ended, and organically evolving compositions, such as the carefully keyed *Three Trees in November* (checklist no. 53, p. 67). Although it conveys a strong sense of specificity, it is best understood as an improvisation.

Peter Poskas divides his time between rural Connecticut and Monhegan Island in Maine. One of his paintings depicts the same buildings seen in Rockwell Kent's *Village at Night*. Like Andrew Wyeth, he repeatedly returns to certain subjects, such as Andres Farm and Lake Waramaug. The small studies, which Poskas works up on site and from memory, are painted on scraps of canvas or panels. His studio transliterations of the studies retain the freshness and specificity of the transient moment— the faint sheen of frost, the early rising mist, the glint of light on new snow—while always

dissecting the regional character and ambience of place. *Toward Olana* (checklist no. 71, p. 68) refers, specifically and metaphorically, to both Frederic Church's picturesque estate in the Catskills and his poetic landscapes (figure no. 3).

Although she is also a Connecticut painter and a realist working from direct observation, nothing could be farther from Poskas' work than the canvases of Margaret Grimes. *Study for the Woods at Night* (checklist no. 36, p. 69) was done entirely on site and, like her other paintings, concentrates on a close-up view of the random clutter of nature. It is an intellectual mix of the close chroma and painterly realism of Welliver, who was her teacher, and the theory of fractals (the random patterns of nature), and is it reminiscent of the decorative, abstract elegance of a Japanese screen.

The painterly plein air realism of Adele Alsop's *Summer Pond* (checklist no. 3, p. 70) is also connected to the pedagogy of Welliver through the graduate program at the University of Pennsylvania. As in *Woods*, the site is difficult to locate geographically, but it is a vigorous and spontaneous summation of place, a layered and perhaps symbolic response, and an ode to the act of painting as a one-to-one response to nature.

Robert Berlind's *Delaware II* (checklist no. 13, p. 71) is a study for a larger canvas. In the flu-idity and directness of its connection to nature, it is reminiscent of a Zen brush drawing. Yet the painting also illustrates the ongoing connections to the post-abstraction, painterly realism of Porter, Freilicher, and Welliver, which provides a formal and intellectual fulcrum for much of the realism produced on the East Coast.

George Nick works almost entirely on site. He studied at the Art Students League with Edwin

Figure no. 3
Frederic Church American, 1826–1900
Twilight in Winter c. 1871–72
Oil on paper, 10$^{1}/_{16}$ x 13 inches
Munson-Williams-Proctor Institute Museum of Art, Utica, New York: Proctor Collection, PC. 21

Dickinson, and through that connection and his painterly proclivities, Nick's work can be considered an extension of the landscape tradition established by F.V. DuMond, William Merritt Chase, and Charles Hawthorne. This connection is easily observed in *Snow Storm* (checklist no. 65, p. 72). For several decades Nick has painted Boston's Back Bay brownstones and Victorian houses from a truck fitted with a skylight. He has traveled widely in Europe, Japan, and the United States, and his oeuvre is extremely diverse. Besides his well-known urban views, Nick has produced an astonishing array of landscapes, still lifes, portraits, self-portraits, interiors, and paintings of automobiles.

Larry Cohen and his brother Bruce Cohen both studied with Paul Wonner. Bruce is noted for his sharply delineated chiaroscuro interiors and still lifes, whereas Larry has concentrated on painterly vistas of southern California and San Francisco. *California Incline* (checklist no. 21, p. 73) depicts the urban sprawl of Santa Monica, with its lush green hills dissected by freeways. For all its lack of specific detail, his crusty, impasto canvas is an uncanny summation of the shifting, transient weather and the flashing glint of light on the verdant landscape, architecture, and water.

While he is best known for his monumental paintings and drawings of beach figures and as one of the most influential teachers in America, Graham Nickson has also produced many small plein air landscapes. More than three decades ago he painted a small *premier coup* sunrise and sunset daily for several months, and in recent years he has returned to the exercise on Long Island, Mount Desert Island in Maine, the Adirondacks, and Australia. *Study for Inlet, Dark Water* (checklist no. 66, p. 74) was painted in the summer of 1986. This directly observed depiction of bathers on a stretch of Long Island beach shows Nickson's strength as a draftsman, colorist, and composer. It served as the study for a monumental three-paneled studio composition he began in 1987 and completed in 1990.

Richard Crozier and Simon Gunning are both southern painters. Crozier works primarily in Charlottesville and Albemarle County, Virginia, although over the years he has painted on site in Michigan, California, New Mexico, Maine, and various parts of the country. His plein air *premier coup* studies, such as *Sycamore at Sugar Hollow* (checklist no. 23, p. 75), are noted for their freshness, warmth, and painterly economy. Gunning, an Australian, now lives in New Orleans and has painted many urban views of that colorful city's backstreets and waterfront. They are filled with the incidents and genre touches so typical of that colorful city. *Krenkel's Pond* (checklist no. 37, p. 76) is a *premier coup* depiction of the swampy, heavily vegetated landscape that is so recognizably indigenous to the Gulf and surrounding area.

One of the major distinctions between the art of our time and that produced a century ago is the abundance of highly distinguished women in contemporary landscape painting. A large number of them have chosen either to work entirely on site or to base their studio compositions on plein air paintings and watercolors. Joellyn Duesberry is best known for her landscape paintings of New Mexico and Colorado, but more recently she has been summering and painting in northern Maine. *Winter Streambed* (checklist no. 27, p. 77), with its earthy tonality, vigorous staccato brushwork, and compressed space, is typical of her landscapes.

Conversely, after having painted in Maine for more than a decade, Sheila Gardner moved to Colorado in 1989. She produces hundreds of small plein air watercolors, and from these she chooses the subjects for her studio compositions. Frequently Gardner returns to the site to paint larger watercolors to provide additional information for the oils. *From Twin to Alice* (checklist no. 32, p. 78) was painted in the studio from her studies, but it typically retains the vitality and clarity of her watercolors.

And last, there are the enigmatic landscapes of the San Francisco painter and printmaker Gordon Cook. These diminutive little canvases either are based on plein air studies or, like his drawings on etching plates, are completed entirely on site. *Delta Moonlight Scene* (checklist no. 22, p. 79) retains the freshness of a plein air painting, but it also has the stripped-to-the-essentials economy of his still lifes. While this work centers on the specificity of observation, it also moves closer to the mysteries of Albert Pinkham Ryder and Giorgio Morandi.

Wayne Thiebaud, a close friend and working associate of Cook's, has written:

> His varied world included interesting (and often improbable) combinations of heroes: Rembrandt and Krazy Kat, Hank Snow and Giorgio Morandi, Jesse Fuller and Piero della Francesca.
>
> Looking at Gordon Cook's works allows us to experience a stubborn belief in responsibility towards lucidity, authenticity, and veracity, and reminds us that art has its own morality.[2]

Delta Moonlight Scene is one of those elusive images that cannot be categorized. In the end, it serves to illustrate the range and depth of the possibilities of plein air painting when it is employed to serve an authentic and distinctly personal vision.

NOTES

1. Rackstraw Downes, quoted in Alexandra Anderson, *Altoon Sultan* (New York: Marlborough Gallery, Inc.), p. 3.

2. Christina Orr-Cahall, *Gordon Cook: A Retrospective* (San Francisco: Chronicle Books, 1987), p. vii.

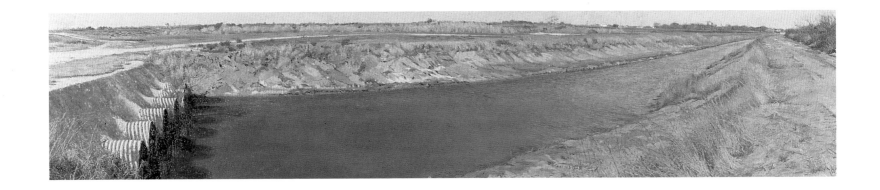

Rackstraw Downes b. 1939 **Rainwater Ditch and Six Culvert Bridge, Texas City, Texas** 1996 oil on canvas 19 x 90 inches

The Philbrook Museum of Art, Tulsa, Oklahoma, museum purchase

checklist no. 26

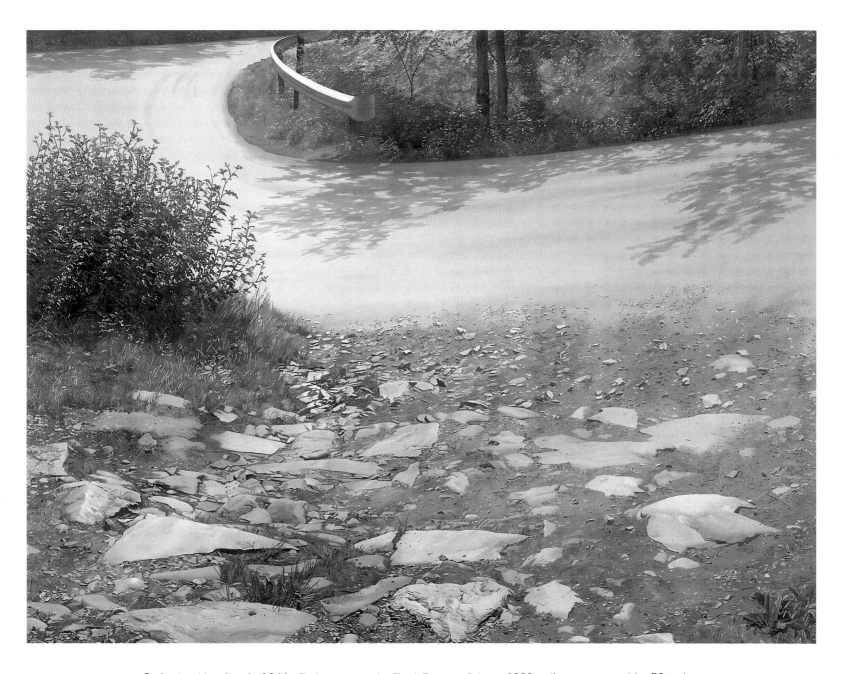

Catherine Murphy b. 1946 **Driveway onto East Dorsey Lane** 1988 oil on canvas 44 x 58 inches

Courtesy of Lennon, Weinberg Gallery, New York

checklist no. 60

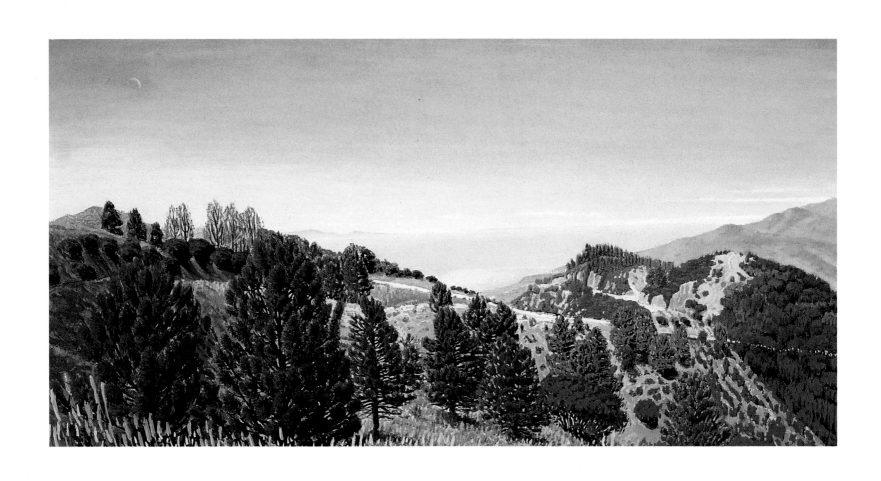

Marjorie Portnow b. 1942 **Camino Cielo II, Santa Barbara (Heaven's Doorway)** n.d. oil on Masonite 15 x 30 inches

Carolina Art Association/Gibbes Museum of Art, Charleston, South Carolina

checklist no. 70

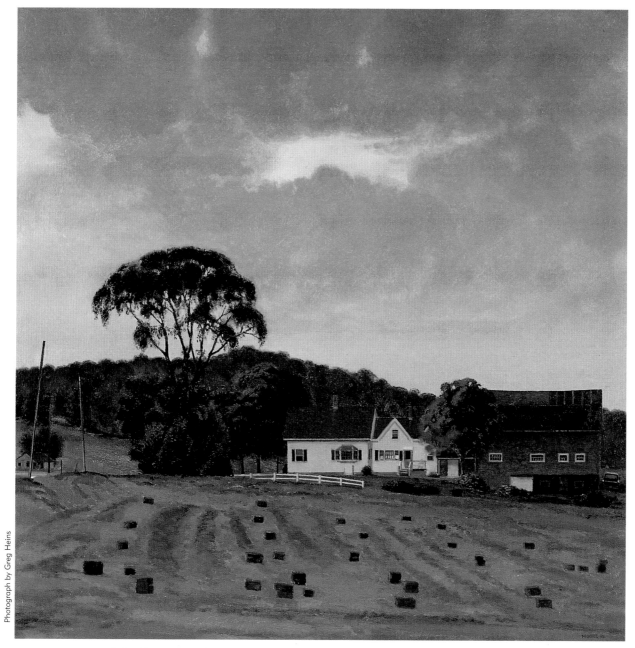

John Moore b. 1941 **Summer Evening** 1993 oil on board 24 x 24 inches
Collection of Frank and Sharon Boltrom, Monroe, Maine
checklist no. 57

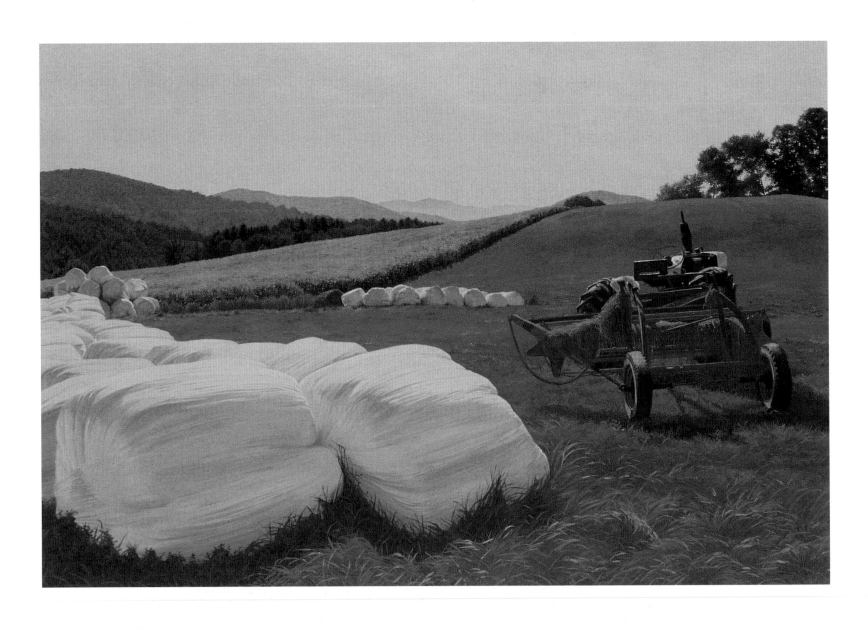

Altoon Sultan b. 1948 **Plastic Wrapped Bales, Barnet, Vermont** 1997 oil on canvas 32½ x 48 inches

Courtesy of Marlborough Gallery, New York

checklist no. 76

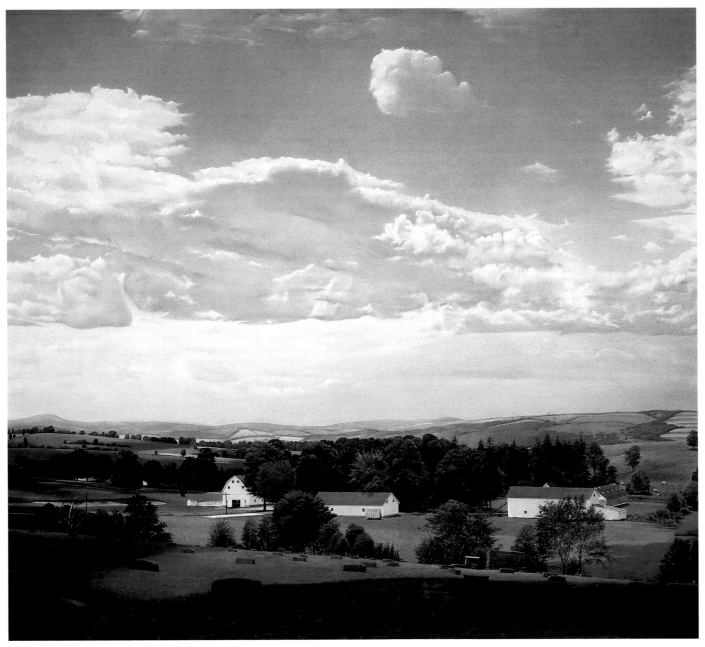

William Beckman b. 1942 **Parshall's Barn** 1977 oil on canvas 63 x 72 inches

Collection of Malcolm Holzman

checklist no. 12

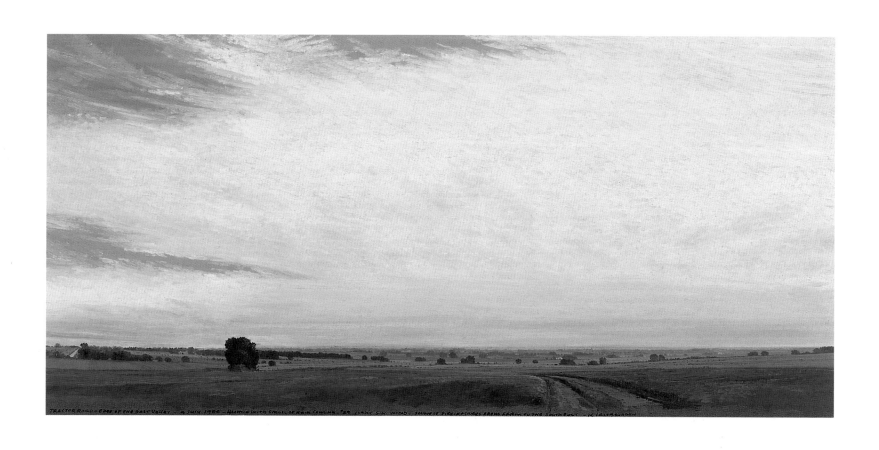

Keith Jacobshagen b. 1941 **Tractor Road-edge of Salt Valley** 1987 oil on paper 8½ X 18¼ inches
The Philbrook Museum of Art, Tulsa, Oklahoma, gift of Thomas E. Matson and Joe Marina Motors
checklist no. 45

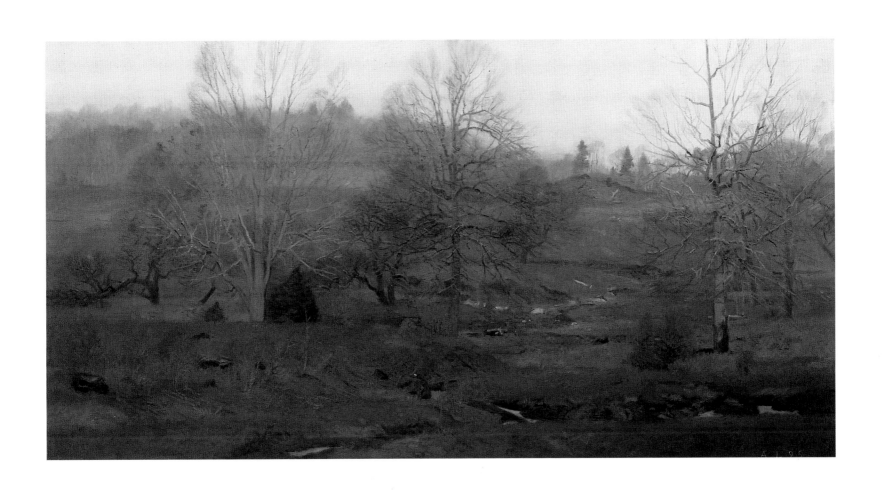

Ann Lofquist b. 1964 **Three Trees in November** 1995 oil on linen 31 x 60 inches
Courtesy of Tatistcheff Gallery, New York
checklist no. 53

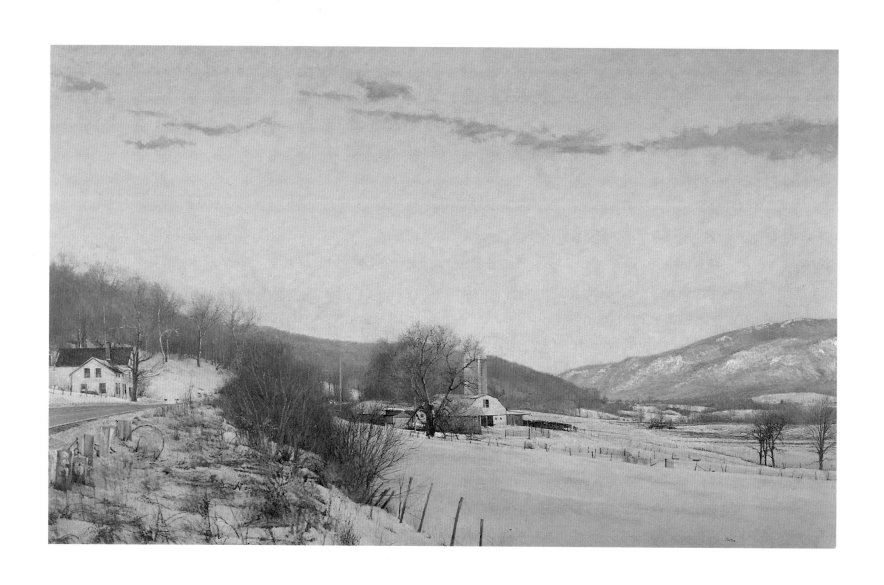

Peter Poskas b. 1939 **Toward Olana** 1995 oil on canvas 29½ x 48 inches
Courtesy of Schmidt-Bingham Gallery, New York
checklist no. 71

Margaret Grimes b. 1943 **Study for the Woods at Night** 1991 oil on canvas 40 x 40 inches

Courtesy of Blue Mountain Gallery, New York

checklist no. 36

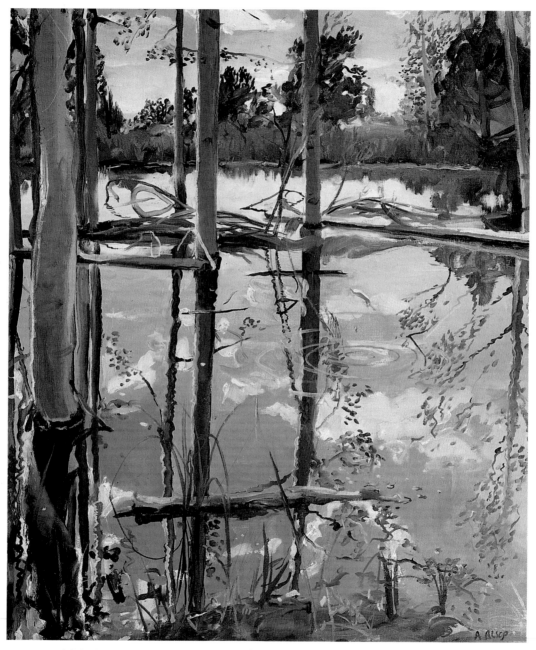

Adele Alsop b. 1948 **Summer Pond** 1987 oil on canvas 42 x 36 inches
Collection of Remak Ramsay, New York
checklist no. 3

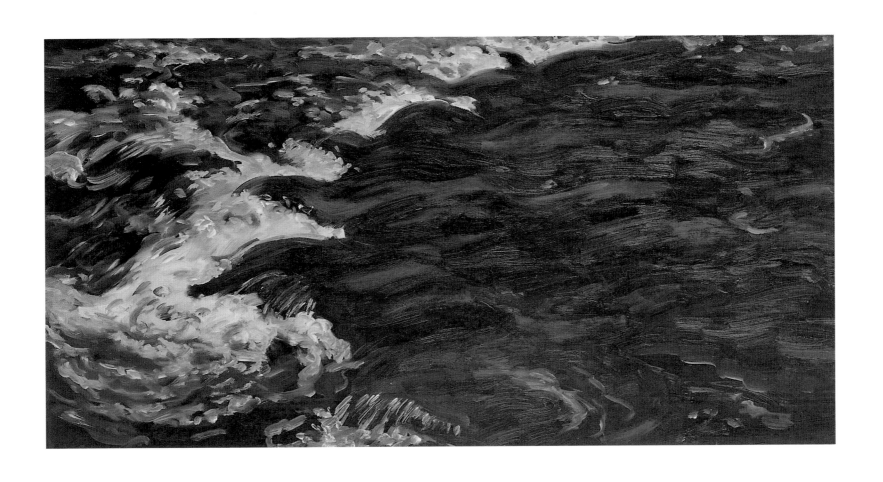

Robert Berlind b. 1952 **Delaware II** 1997 oil on board 12 x 24 inches
Courtesy of Tibor de Nagy Gallery, New York
checklist no. 13

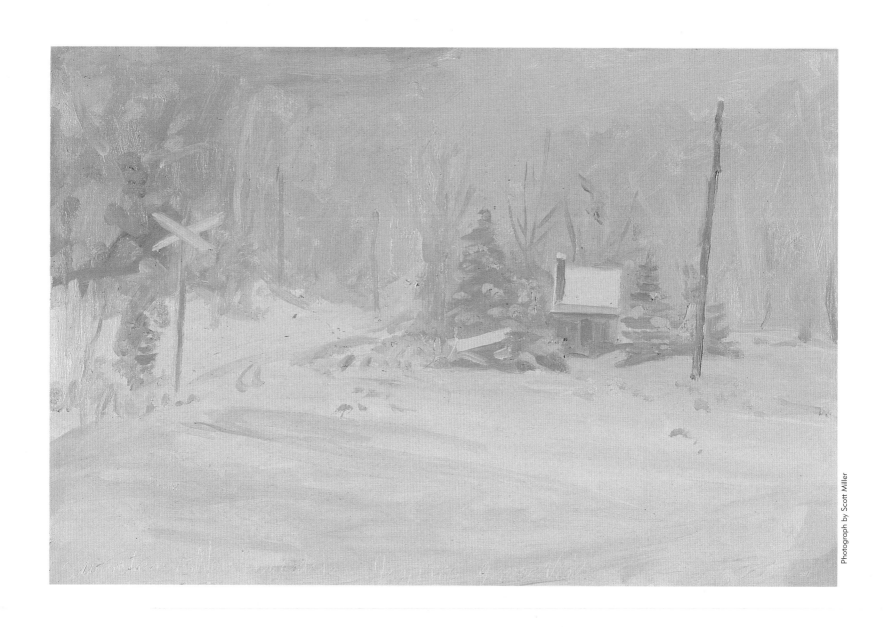

George Nick b. 1927 **Snow Storm** 1986 oil on canvas 20 x 30 inches
Courtesy of Howard and Beverly Zagor
checklist no. 65

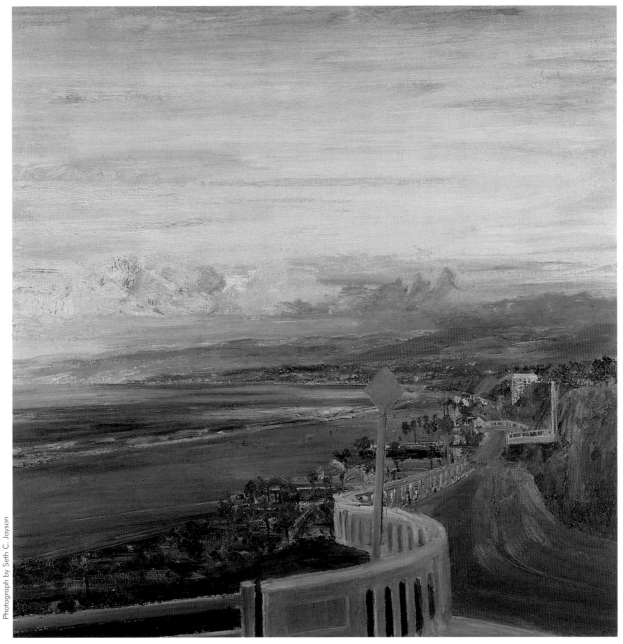

Larry Cohen b. 1952 **California Incline** n.d. oil on canvas 40 x 40 inches
Collection of Terry and Eva Herndon
checklist no. 21

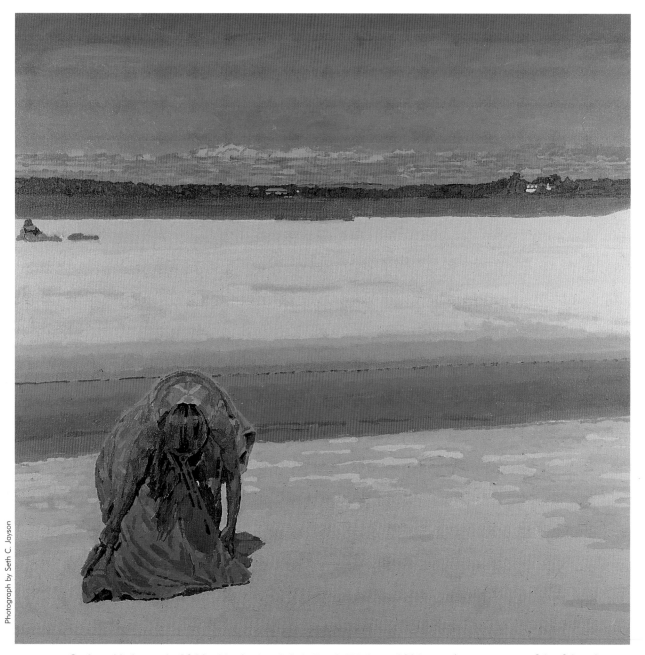

Photograph by Seth C. Jayson

Graham Nickson b. 1946 **Study for Inlet, Dark Water** 1986 acrylic on canvas 36 x 36 inches
Courtesy of Salander-O'Reilly Galleries, New York
checklist no. 66

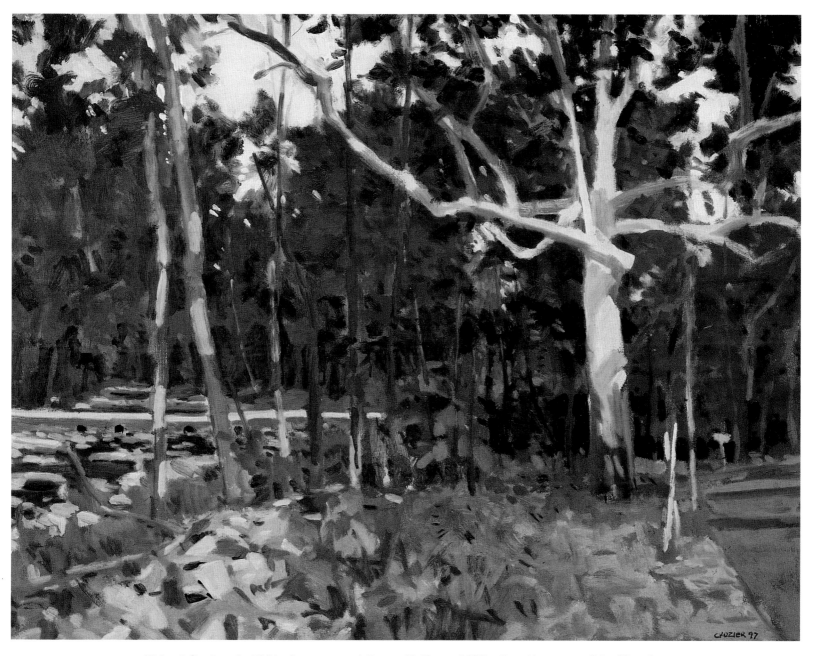

Richard Crozier b. 1944 **Sycamore at Sugar Hollow** 1997 oil on Masonite 24 x 32 inches

Courtesy of Tatistcheff Gallery, New York

checklist no. 23

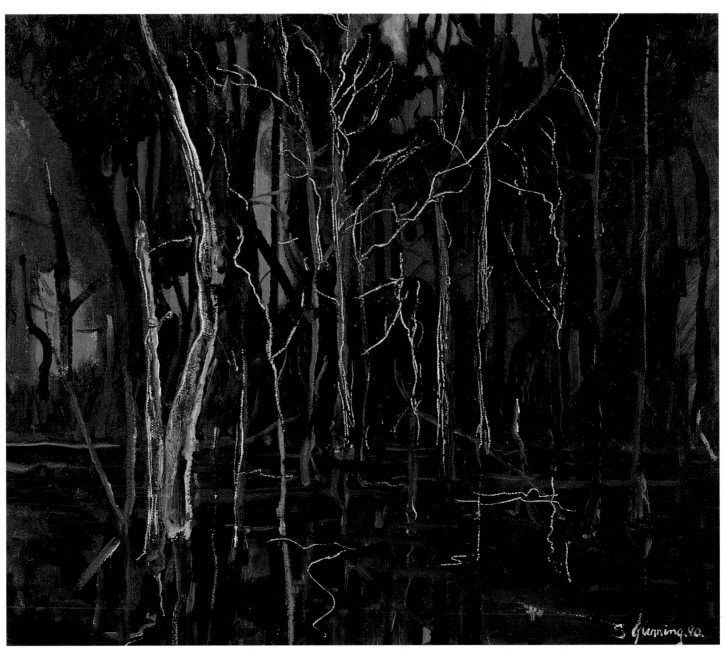

Simon Gunning b. 1956 **Krenkel's Pond** 1997 oil on canvas 20 x 22 inches

Courtesy of Galarie Simonne Stern, New Orleans, Louisiana

checklist no. 37

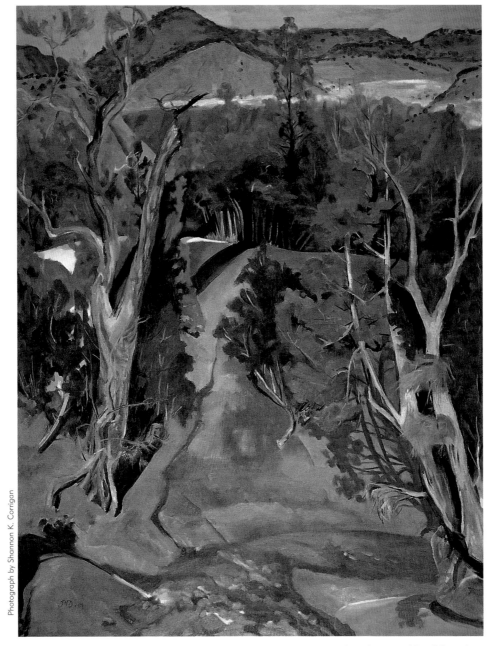

Joellyn Duesberry b. 1944 **Winter Streambed** 1989 oil on linen 40 x 30 inches
Collection of the artist, Denver, Colorado
checklist no. 27

Sheila Gardner b. 1933 **From Twin to Alice** 1997 oil on canvas 50 x 60 inches
Courtesy of Gail Severn Gallery, Ketchum, Idaho
checklist no. 32

Gordon Cook 1927–1985 **Delta Moonlight Scene** n.d. oil on canvas 14 x 16 inches

Courtesy of Schmidt-Bingham Gallery, New York

checklist no. 22

4 Photorealism and Photo-Derived Painting

things with its gaze, but enters within them, as things enter it. It allows us to come amidst things.

"Art, and above all painting, has always known this. . . ."

Henning Weidemann[1]

"Decartes . . . saw with consciousness alone. For him, vision is a conditioned thought, produced on the basis of the thing seen. The eye is conceived as a frontal confrontation with what is seen. Descartes' vision is the gaze of the camera. Only on a photo does it become perfectly clear: Descartes thinks without his body. His conceptual eye, like the lens of the camera, confronts the world frontally and in stillness. Yet we do not live before the world, but in it. Our eye does not merely prod

The closely entwined relationship of painting and photography has often been understated or completely ignored in most of our accounts of art history. Yet the earliest methods of obtaining a stable, light-induced image were invented by Louis Jacques Mandé Daguerre, his collaborator Joseph Nicéphore Niepce, and William Henry Fox Talbot. Daguerre was a painter and set designer, Niepce was a gifted amateur painter, and Talbot was an artist, naturalist, and scientist.

Photography, from its beginnings in pinhole projection and the camera obscura to the light-sensitive copper plate invented by Daguerre in 1839, has been tightly interwoven with painting and the graphic arts. Throughout history, almost every artist has used systems and devices for reproducing the spatial world on a flat surface, and for measuring and maintaining proportions. Daguerre provided the painter with a permanent and convenient image and simultaneously created another art form: photography.

Talbot's early photographs were described as "photogenic drawings" and Eugène Delacroix expressed his regret that photography had been invented too late for him. Eugène Cuvelier and other mid-nineteenth-century photographers sold albums to landscape painters visiting the Fountainebleau Forest. Since its invention, photography has been a major tool for artists such as Gérôme, Alma-Tadema, Courbet, Millet, Homer, Bierstadt, Mucha, Munch, Bonnard, and many others. Beyond their well-known paintings, prints, and sculpture, Thomas Eakins, Edgar Degas, Edouard Vuillard, Man Ray, Ben Shahn, Charles Sheeler, and Constantin Brancusi produced a significant body of work in this medium.

In the art of our time there are major historical and procedural misunderstandings surrounding the emergence of photo-derived and photo-replicative painting. Photorealism, which is a facet of contemporary art that now spans more than thirty years, is still widely regarded as a phenomenon of the seventies. The idea that it evolved from Pop Art has persisted, while the obvious connection to documentary photography is rarely mentioned. These errors have been repeated for at least the past two decades by many critics and art historians. Also, there is the persistent misconception that Photorealist painting has focused almost entirely on assembly-line objects and the visual cacophony of contemporary urban culture.

Nor does most Photorealist painting center on the sleek, mimetic replication of the visual characteristics of photography while minimizing evidence of the hand.

For example, in the mid-sixties the late Lowell Nesbitt painted a series of photo-derived canvases depicting the cast-iron façades along Fourteenth Street in New York in the area now known as SoHo. A few years later Malcolm Morley replicated glossy travel and cruise advertisements on a monumental scale; John Clem Clarke produced stenciled, spray-painted versions of the old masters; Chuck Close airbrushed a group of monumental grisaille heads; and Richard Estes was acknowledged as a masterly contemporary vedutist (view painter).

Simultaneously, the West Coast painters working from slides and photographs reflected their inclination toward genre subjects: Robert Bechtle's automobiles parked in front of quiet suburban houses, Richard McLean's images of the rodeo and horse culture, and Ralph Goings' snapshot portraits of young women.

Concurrently, Joseph Raffael had moved past his collage-like multiple-image paintings derived from randomly selected magazine clippings and completed a group of portraits of Native Americans. They were inspired by his attraction to the spiritual aspects of nature, as were his large, jewel-like close-ups, *Oyster* and

Salmon, which were painted at the close of the sixties. By the early seventies Raffael had produced photo-based animal portraits such as *Lizard* and *Lion*, and since that time, birds, fish, animals, and insects have populated his lush, decorative canvases and watercolors. From the beginning they have been used as expressive and symbolic vehicles for the mystical, religious, and poetic aspects of nature. Raffael's landscapes, from his sensual and effervescent close-ups of flowers and foliage, such as *The Garden after the Rain, the Sun Comes Out* (checklist no. 72, p. 86), to those images of dark, swift streams frozen in momentary glittering of light, are among the most seductive works in contemporary art.

Richard Estes' paintings from the late sixties were extremely deceptive when seen in small reproductions in periodicals such as *Life*, *Sports Illustrated*, and *New York Magazine*, which provided the earliest introduction of his work to a broad public. The early canvases are beautifully rendered and quite painterly, characteristics that were always lost in the reproductive process. He has never based his paintings on projected slides and has always taken compositional liberties with his subjects. These factors have remained consistent throughout his career. Although Estes will always be considered primarily as a chronicler of the streets and views of Manhattan, he has traveled extensively and has produced numerous canvases and prints of European cities—Paris,

Venice, Barcelona, Rome, Tokyo, London—from 1975 to the present. His first major Staten Island Ferry panorama was done more than a decade ago, and this group of canvases marks the beginning of Estes' meandering movement toward pure topographical painting. His first major landscape, *Miletus* (checklist no. 28, p. 87), depicts an archaeological ruin in Turkey. Whereas his urban scenes connect with Canaletto, Bellotto, and urban veduta, this expansive panorama with its deep space and dramatic sky can best be considered an homage to Claude Lorraine and the European landscape tradition.

Harold Gregor, an influential Illinois State University professor, began painting the corncribs, farms, and plowed fields of the fertile plains of the Midwest in 1971. His first photography-based landscapes depicting the vast tilled earth and big skies of Illinois were painted in 1971. *Illinois Landscape #124* (checklist no. 35, p. 88) is typical of Gregor's landscapes, which are clear-eyed, assiduously unsentimental, and devoid of the narrative bombast that weighed down the Regionalism of Thomas Hart Benton, John Steuart Curry, and Grant Wood in the thirties.

With an esthetic past that stretches back to Pop themes appropriated from mass culture, Idelle Weber moved from cool Photorealist images of gardens and urban detritus to the bravura painting and rich chiaroscuro of the

dramatic *Short Thunder* (checklist no. 82, p. 89). This painterly, romantic view typifies her more recent endeavors as a landscape painter.

Although James Valerio is best known for his monumental and often provocative narrative paintings, he has also produced an array of remarkable tour-de-force still lifes over the last two decades. His forays into landscape drawing and painting are rather rare, but the large canvas, *Backyard* (checklist no. 80, p. 90), clearly indicates that his quirky, enigmatic vision carries over into the act of gardening. Valerio's hostas, marigolds, and leaves float randomly in the dark soil like the distant stars and galaxies revealed by the Hubbell telescope.

Conversely, Carolyn Brady's intimate and seductively lush garden close-up, *Red and White Parrot Tulips Unfolding* (checklist no. 16, p. 91), is a painterly transliteration of her color photograph. It alludes to nothing beyond the image. Brady moved from sewn appliqués based on home shelter magazine photographs of interiors to painting small watercolors from her own photographs. She makes a very cursory drawing from a projected color negative and paints from a color print of the photograph. Like her friend Joseph Raffael, whom she has known since her early days in New York as a fabric designer, Brady incorporates the focal blur, lush color, and tonality of her photographic source material. She and Raffael

are highly regarded for their superb skill with this transparent medium.

The sensibilities of Yvonne Jacquette and Susan Shatter have always been closely aligned with the painterly realism of Fairfield Porter, Alex Katz, and Neil Welliver, and both are extremely adept at the practice of plein air painting. It is obvious that Jacquette's magical neon nights and aerial views, such as *Double Wing Sunset* (checklist no. 46, p. 92), would be impossible to achieve without the aid of the camera, and equally clear that Shatter's photo-derived *Indian Point* (checklist no. 74, p. 93) and her other landscapes are backed up by an assortment of watercolor studies done on site. Shatter was the first of the contemporary watercolorists to begin making large-scale paintings, a practice started by Charles Burchfield. Whereas Burchfield glued together sheets of paper, Shatter found a highly absorbent manufactured paper that could be purchased in rolls. Today, this is such a common practice that many of the best papermakers produce both very large sheets and rolls of handmade papers.

Brooks Anderson and Peter Holbrook are California artists. Holbrook has a long history that stretches back to a group of highly finished, photo-replicative grisaille nudes painted in Chicago in the late sixties, but he has concentrated entirely on the landscape for more than twenty-five years. Although his water-

colors, acrylics, and oils are not as broadly painted or as gestural as Shatter's, they clearly show evidence of his hand, and like Shatter's oils and watercolors, his subjects cover a broad geographic and topographical range. While Brooks Anderson's *Cathedral* (checklist no. 5, p. 94) depicts a similar subject, his coastal view stands in sharp contrast to Holbrook's *Nightfall—Harris Beach* (checklist no. 41, p. 95), for Anderson's lucid images of northern California are openly romantic and much more inclined toward mood.

Like many of the other contemporary painters, Woody Gwyn, Daniel Morper, James Butler, Joel Babb, and William Nichols have concentrated primarily on the regional specifics of landscape.

As can be seen in *Interstate Roadcut* (checklist no. 38, p. 96), Gwyn can capture the blistering heat and dry, clear atmosphere of the New Mexico landscape better than almost any other contemporary artist. Like Gwyn, Daniel Morper paints in the Santa Fe area. He gave up a career in law to take up painting and print-making. Before moving west, Morper painted New York views, and he has done an impressive group of paintings of Grand Canyon. His most recent work centers on the railroad in and around Santa Fe and other small towns in New Mexico. The sparse, flat landscape of *The Last Signal* (checklist no. 58, p. 97) is bathed in the warm golden glow of the early light and

the desert and scrubby flora are broken by the metallic glint of sun on the receding curve of tracks.

Butler has concentrated on the great expanses of the heartland plains. While the beautiful *Landscape with Pond* (checklist no. 19, p. 98) is indicative of his facility and the character of his work, it gives no hint of the skill, capabilities, and fortitude displayed in his monumental series of canvases that trace the Mississippi River from its origin to the Louisiana coast.

The Maine artist Joel Babb and Floridian Jim Nichols render the fractured light, dense, overgrown clutter, and anonymity of the woods, but each takes these vegetative webs and tangles in a different direction. Babb, who is best known for large panoramic urban views, places the emphasis on light and color, as can be seen in *Wilkinson's Brook* (checklist no. 8, p. 99), whereas Nichols structures his compositions such as *Creek at Sunset* (checklist no. 64, p. 100) around the elaborate chiaroscuro of the dense, lace-like foliate patterns.

Light always played a key role in Sarah Supplee's pastels and paintings, but rather than using the dramatic chiaroscuro of the Mannerists, she relied instead on the subtleties of naturalistic light to convey the quiet, delicate moods of the landscape. She admired the Flemish and Pre-Raphaelite painters and acknowledged a connection to the Dutch

Realists, German Romantics, and the Hudson River school. Supplee considered her work to be an extension of those traditions, particularly the Hudson River painters and American Luminists. The small canvas *Blackberry Vines* (checklist no. 77, p. 101), which is one of her more intimate glimpses of nature, reflects those connections and also indicates an admiration for the pastels of dandelions and flowers by Millet.

The division between the painters' use of photography and their reliance on perceptual observation was so sharp in the late sixties and seventies that the differentiation served as an esthetic Maginot Line in the realism and figurative painting of that period. Fortunately, it is a distinction that has long since crumbled, and today such perimeters are frequently quite blurred.

NOTES

1. Henning Weidemann and Daniel Challe, *Eugène Cuvelier* (Stuttgart, Germany: Cantz Verlag, 1996), p. 13.

Joseph Raffael b. 1933 **The Garden after the Rain, the Sun Comes Out** 1990 watercolor on paper 44 x 68 inches
The Philbrook Museum of Art, Tulsa, Oklahoma, museum purchase in honor of Robert Lorton for his service as chairman of the board, 1992–1994
checklist no. 28

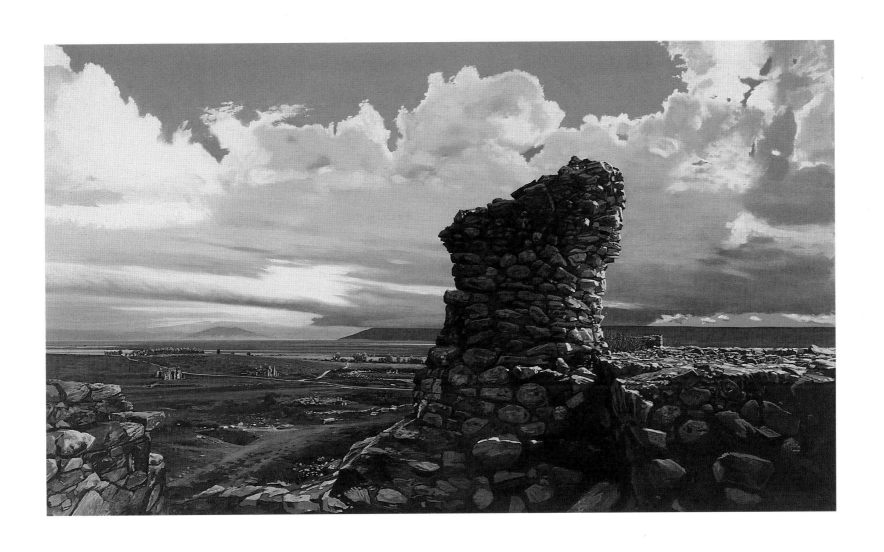

Richard Estes b. 1932 **Melitus** 1999 oil on canvas 35 x 60 inches
Lent by the artist, courtesy of Marlborough Gallery, New York
checklist no. 28

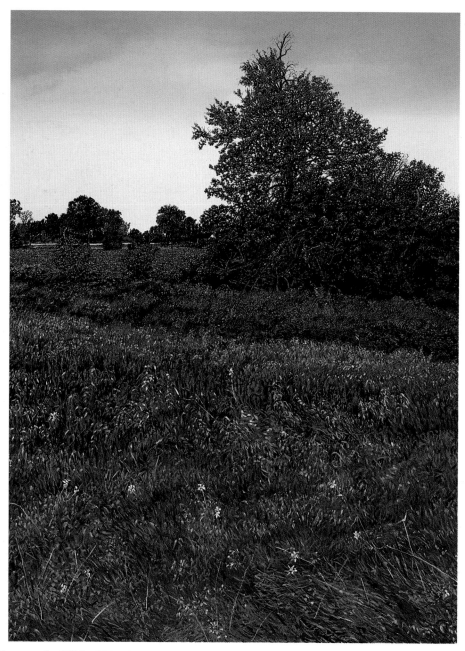

Harold Gregor b. 1929 **Illinois Landscape #124** 1993 oil and acrylic on canvas 82 x 60 inches
Courtesy of Elliot Smith Contemporary Art, Saint Louis, Missouri
checklist no. 35

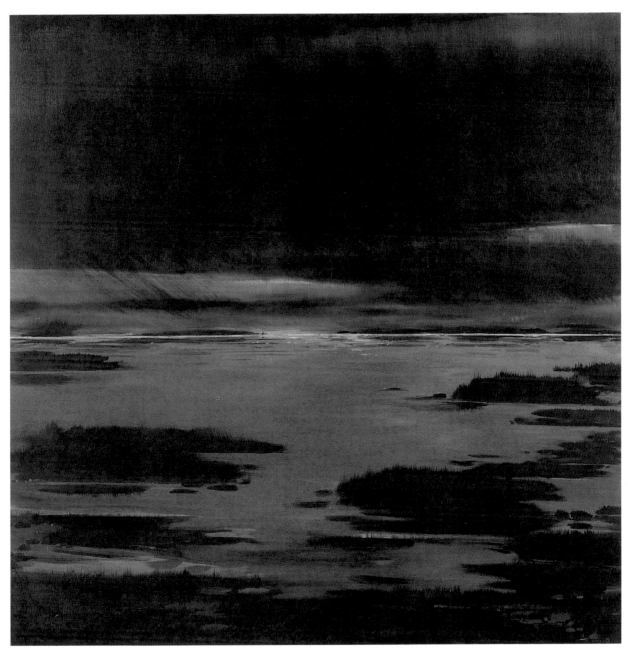

Idelle Weber b. 1932 **Short Thunder** 1993 oil on linen 47 x 47 inches
Courtesy of Schmidt-Bingham Gallery, New York
checklist no. 82

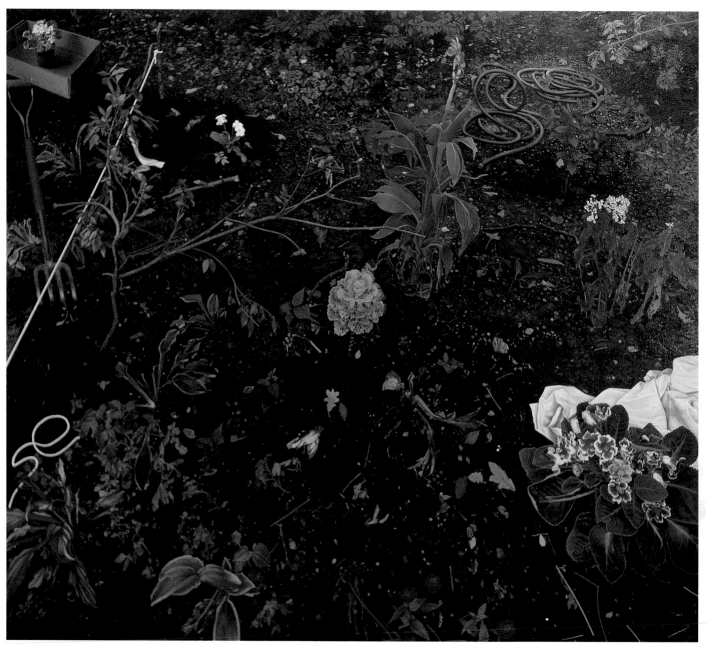

James Valerio b. 1938 **Backyard** 1993 oil on canvas 84 x 96 inches

Private collection

checklist no. 80

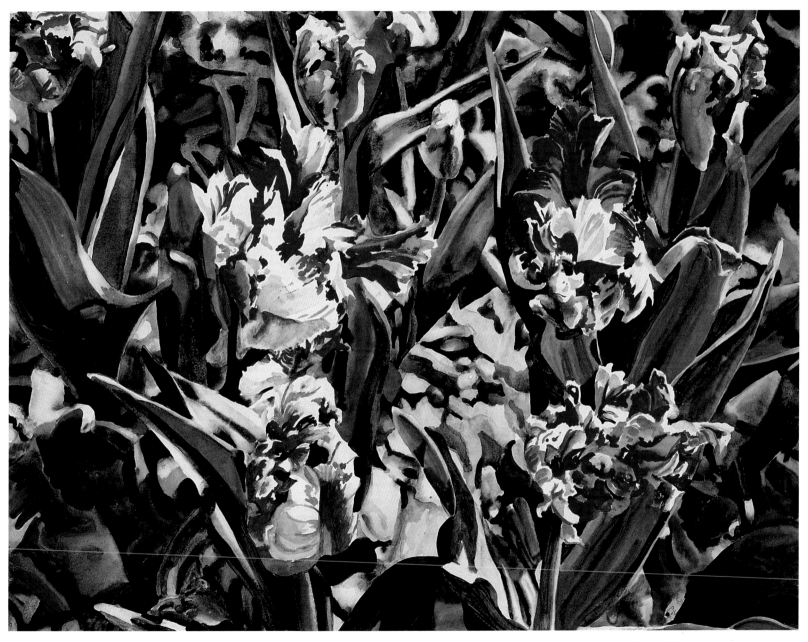

Carolyn Brady b. 1937 **Red and White Parrot Tulips Unfolding** 1987 watercolor on paper 18¼ x 23¾ inches

Farnsworth Art Museum, Rockland, Maine, gift of the artist, 1987

checklist no. 16

Photograph by Kevin Ryan

Yvonne Jacquette b. 1934 **Double Wing Sunset** 1995 pastel 19⅜ x 14¼ inches
Private collection, courtesy of D. C. Moore Gallery, New York
checklist no. 46

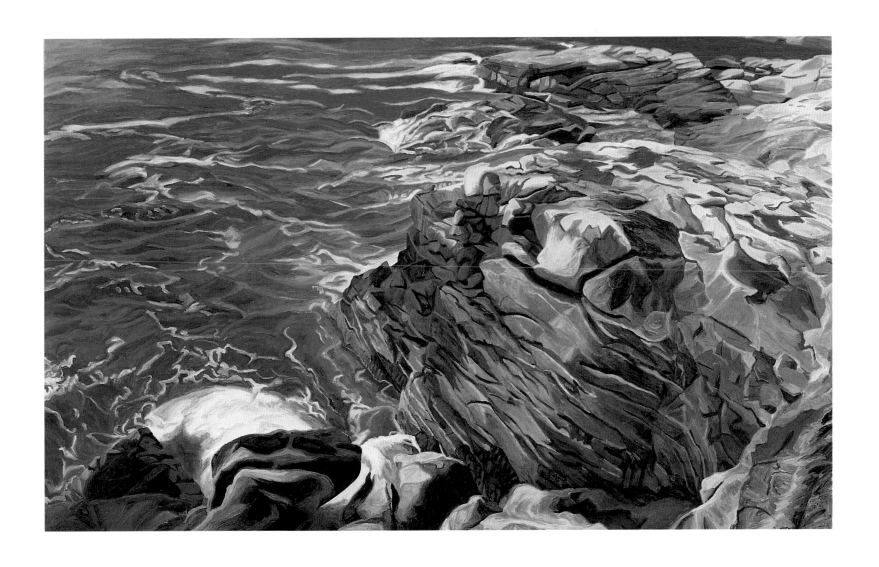

Susan Shatter b. 1943 **Indian Point** 1984 oil on canvas 45 x 75 inches
Courtesy of the artist
checklist no. 74

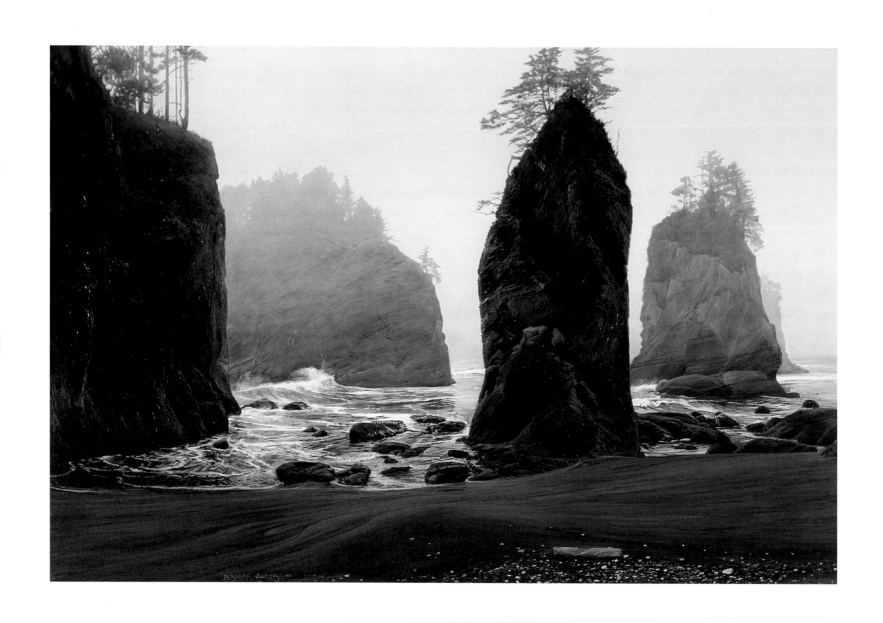

Brooks Anderson b. 1957 **Cathedral** 1991 oil on canvas 48 x 72 inches
The Philbrook Museum of Art, Tulsa, Oklahoma, museum purchase in honor of Jon R. Stuart
for his service as chairman of the board of trustees, 1997–1999
checklist no. 5

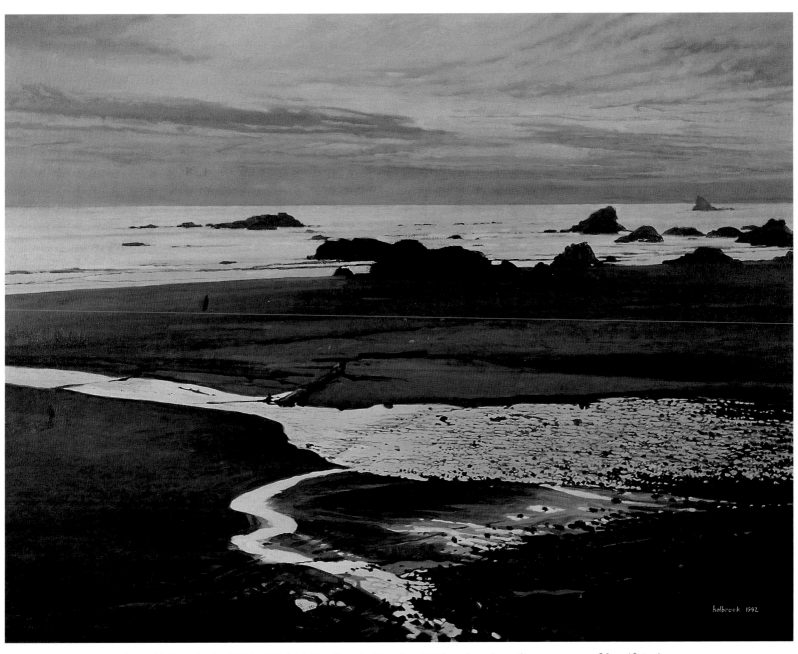

Peter Holbrook b. 1940 **Nightfall—Harris Beach** 1992 oil and acrylic on paper 31 x 40 inches

Courtesy of the artist

checklist no. 41

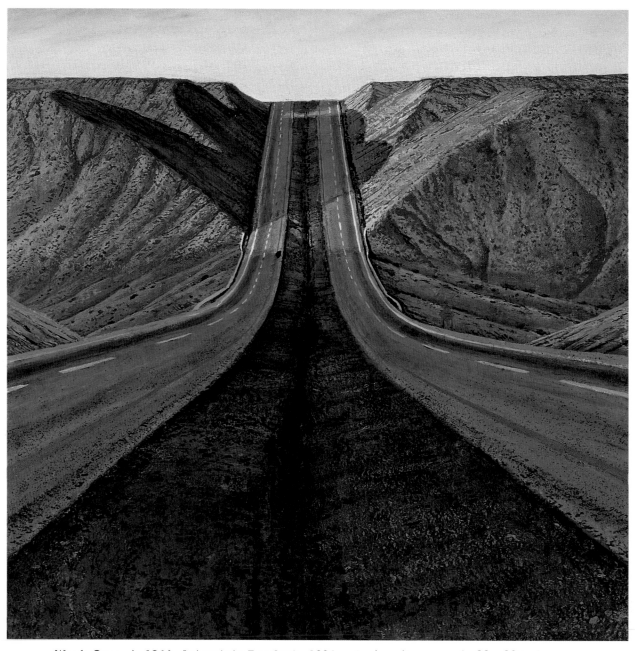

Woody Gwyn b. 1944 **Interstate Roadcut** 1996 mixed media on panel 22 x 22 inches

Courtesy of Gwyn and Gwyn Arts, Ltd.

checklist no. 38

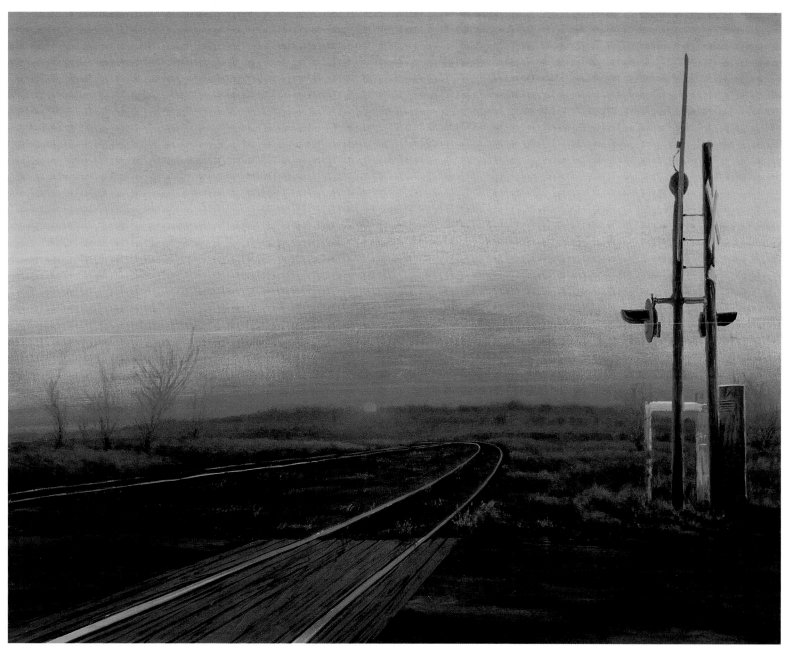

Daniel Morper b. 1944 **The Last Signal** 1998 oil on canvas 24 x 30 inches

Courtesy of Tatitscheff Gallery, New York

checklist no. 58

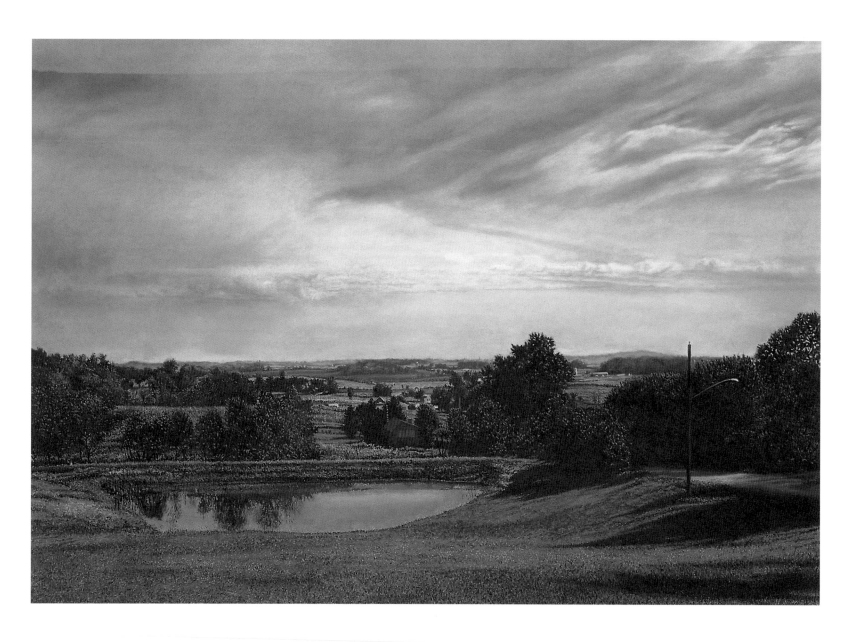

James Butler b. 1945 **Landscape with Pond** 1984 pastel on paper 30 x 42 inches

Collection of Stephen Alpert, Boston, Massachusetts

checklist no. 19

Photograph by Melville McLean

Joel Babb b. 1945 **Wilkinson's Brook** 1997 oil on canvas 54 x 42 inches

Courtesy Frost Gulley Gallery, Portland, Maine

checklist no. 8

William Nichols b. 1942 **Creek at Sunset** 1998 oil on linen 50 x 78 inches
Courtesy of Tory Folliard Gallery, Milwaukee, Wisconsin
checklist no. 64

Sarah Supplee 1947–1997 **Blackberry Vines** 1990 oil on linen 12 x 24½ inches
Estate of Sarah Supplee, courtesy of Tatistcheff Gallery, New York

checklist no. 77

5

The Landscape Interpreted

Figure no. 6
Winslow Homer American, 1836–1910
High Cliff, Coast of Maine 1894
Oil on canvas, 30⅛ x 38¼ inches
National Museum of American Art,
gift of William T. Evans

"I think I see nature with a more complicated eye than earlier. Where once a fleet of clouds blown by a wind across the ragged sky was enough for me, now I look at it, trouble how best to put it down. When this—the grammar of expression—has become as much a part of me as seeing, then can I return to my simpler sight."

Charles Burchfield
February 11, 1911[1]

The layers of interpretation of the natural world are endless. In our century alone there are the plein air poetics of Winslow Homer (figure no. 6), George Bellows, and Rockwell Kent; the visionary images of George Inness, Albert Pinkham Ryder, and Joseph Stella; the anxious expressionism of Marsden Hartley; and the idyllic world created by Maxfield Parrish. Georgia O'Keeffe took what she needed from William Merritt Chase and Arthur Wesley Dow and decades later turned the desert of New Mexico into a hallucinatory form of naturalism. Her friend Arthur Dove translated his response to the American landscape into elegant and deeply personal abstractions. During the same period, Charles Burchfield devised a pictographic means of describing the

mood, weather, movement, and sounds of the natural world.

Starting with Burchfield's early notion of expressionism as being an intensification and codification of one's response to any motif, the painterly landscapes of Paul Resika, Paul Georges, and Bernard Chaet illustrate the formal and visual nuances of the directly observed landscape after the advent of Abstract Expressionism. They are from the generation of artists that had direct contact with Hans Hofmann, Willem de Kooning, Mark Rothko, Jackson Pollock, and other prominent figures from that watershed period in American art. Their paintings are rendered in plein air and are often done *premier coup*, or in one sitting. Resika's fresh, airy views are reduced to their essentials and have a decidedly French inclination, as his *Horse Leech Pond* (checklist no. 73, p. 108) clearly indicates. Georges is best known for his bravura rendering and large allegorical paintings. His *Calla Lillies* (checklist no. 33, p. 109) is vigorously gestural. Chaet is more inclined toward the shifting nuances of nature at a given moment in time, as can be seen in his *Changing Light* (checklist no. 20, p. 110).

Even though the Santa Fe painter Forrest Moses has chosen to live in the arid landscape of New Mexico, his lush canvases and monoprints are lyrical interpretations of the northeastern woods and streams. *Slow Water at*

Chadd's Ford (checklist no. 59, p. 111) corresponds to a very different aspect of the rural area in Pennsylvania made familiar to millions by Andrew Wyeth.

John Alexander carries the interpretive landscape into another generation. His sinewy, staccato rendering of the landscape *Late Summer Behind the Studio* (checklist no. 1, p.112) is based on direct observation.

Jon Imber studied with the late Philip Guston, whose post-Abstract Expressionist paintings of hooded buffoons, wide-eyed late-night smokers, French fries, insomniacs' clocks, and abandoned shoes have been a major influence on two generations of figurative painters. Imber's narrative and allegorical paintings are centered on an edgy, autobiographical neurosis similar to the apprehensiveness that lies at the core of Guston's anxiety-ridden themes, but his plein air Maine landscapes, such as *The Ledge* (checklist no. 43, p. 113), owe more to Hartley and are highly animated celebrations of nature.

The paintings of Bill Sullivan, like those of a number of his contemporaries, reflect a reverence for the nineteenth-century American Luminists, and in particular the transcendental landscapes of Frederic Church (figure no. 5, p. 104). In fact, Sullivan has actually visited many of the South American sites Church painted. His romantic *La Vida* (checklist no. 75, p.

114), with its islands, tropical palms, and sun sinking in a mauve sky, veers dangerously close to the picturesqueness and sentimentality of such scenic clichés without going over the edge. It is a risky endeavor.

In direct opposition to this stance, Daniel Lang has instilled a sense of poetry and hushed mysteries into his commonplace interiors, still lifes, and landscapes. Lang has produced a body of landscape drawings, prints, and paintings that ranges from the open vistas of Oklahoma to the lush countryside of Italy and

the frozen spectacle of Antarctica. The shady, tree-lined walk, *Quincy Light* (checklist no. 50, p. 115), painted in 1985, is more reminiscence than fact. It refers to a street in Quincy, Illinois, where Lang had visited as an artist in residence two decades earlier.

Patricia Tobacco Forrester paints exclusively with watercolor and on location. She is a restless itinerant, traveling four months out of the year and moving constantly toward the heat and sun of northern California and rural France, the tropics of South America, and other exotic locations. Although her landscapes, such as *Blackest Peonies* (checklist no. 29, p. 116), are painted in situ, they never replicate a specific view. Instead, they are rearrangements of her surroundings—the lush vegetation, colorful flowers, twisting trees, and mountain streams—interwoven with her reminiscences. Forrester's watercolors are best comprehended as a delicate blending of the particulars of place with her personal musings.

The elegant canvases of Augustus Tack, the abstractions and collages of Arthur Dove (figure no. 7, p. 106), and the symbols that animate many of Charles Burchfield's watercolors refer to the moods, sounds, sensations, and unseen aspects of nature. Their works differed from realism, naturalism, and the expressionism of Marsden Hartley (figure no. 6, p. 105), for example, in that the intensification of their personal response to nature domi-

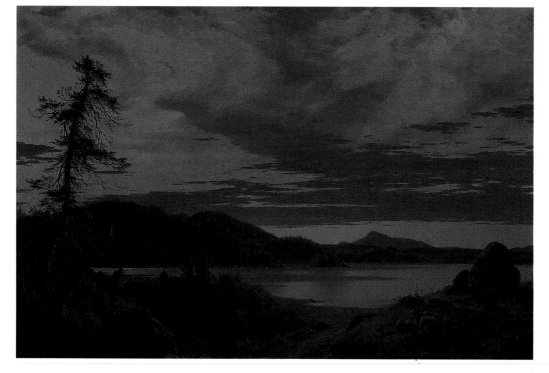

figure no. 5
Frederic Church American, 1826–1900
Sunset c. 1856
Oil on canvas, 24 x 36 inches
New York State Offices of Parks, Recreation and Historical Preservation

nates the visual characteristics. Today, some of the most distinguished abstract painters have followed a similar path. Like the second generation of realists and figurative artists, most of them matured as painters and came to prominence in the seventies. As mentioned earlier, criticism in the art world during this decade was dominated by Rosenbergian, Greenbergian, and Formalist esthetics and its spinoffs, and was distinguished by a prevailing institutional bias against contemporary realism and figuration. Such attitudes have remained in place throughout the nineties, except for the airbrushed paintings of Chuck Close, whose heightened realism has been broadly accepted because of its conceptual and procedural orientation. Clement Greenberg never forgave Richard Diebenkorn for his figurative work in the fifties and sixties, nor did he approve of Diebenkorn leaving too many traces of his struggles and reworkings in his *Ocean Park* paintings. It is logical to surmise that Greenberg would have found the content-oriented abstractions of Katherine Porter, John Moore, Terence La Noue, Caio Fonseca, Gregory Amenoff, and Jim Waid to be very much against the Formalist grain, even though their works, like the paintings of Morris Louis, Kenneth Noland, and Jules Olitski, have evolved from Abstract Expressionism.

While predominantly abstract, the paintings of Amenoff and Waid are laden with overt references to nature. Most of Amenoff's large can-

Figure no. 6
Marsden Hartley American, 1877–1943
Eight Bells Folly: Memorial to Hart Crane 1933.
Oil on canvas, 30⅝ x 39⅜ inches
Frederick R. Weisman Art Museum at the University of Minnesota, Minneapolis, gift of Ione and Hudson Walker

vases have recognizable elements—stars, water, dark shorelines, trees, lightning, and ominous clouds—and many of his symbolic titles are keyed to the landscape. In addition, the air of melancholic mystery that frequently permeates his paintings, the recurring chunky shapes, and the thick, crusty passages of pigment are reminiscent of the paintings of Albert Pinkham Ryder (figure no. 8, p. 107). Other

Figure no. 7
Arthur Dove American, 1880–1946
Plant Forms c. 1912
Pastel on canvas, 17¼ x 23⅞ inches
Whitney Museum of American Art, New York,
purchase, with funds from Mr. and Mrs. Roy R.
Neuberger

aspects, such as the spiky stars and undulating, repetitive forms, recall the landscapes of Charles Burchfield. In a recent departure from his large abstractions, Amenoff has produced a series of small works such as *View, #36* (checklist no. 4, p. 117). The expressive and formal qualities and vigorous, sinewy rendering that have typified his work over the past two decades are compressed rather than diminished in these little panels.

Jim Waid, an Arizona artist, is at his best when working on a monumental scale. Given that circumstance, his *Olla* (checklist no. 81, p. 118) is a bit of an anomaly. The elaborateness, rich color, and tactility are typical of his paintings. As in Amenoff's work, there is a strong sense of physicality and energy. Both veer from abstractions to compositions that are filled with recognizable forms, icons, and pictographs without a loss of identity. Waid's canvases are built up in chromatic layers with much overpainting, scraping, and troweling, which expose their stratification of jewel-like colors. Like Amenoff's paintings, these are among the most distinctive and authoritative abstractions in contemporary art.

Even when derived from unfettered empirical observation, all vision is ultimately subjective. This can be seen in the subtle shifts of descriptive specificity employed by Rackstraw Downes, William Beckman, and Catherine Murphy. It can be detected more noticeably in the differ-

ences between Richard Claude Ziemann's poetic image *Cricklewood Pond* (checklist no. 89, p. 119), which is drawn on the etching plate directly from the landscape, and Peter Milton's tactile intaglio inventions. More extreme is the polarity between Bill Sullivan's intensification of local color and Patricia Tobacco Forrester's fusion of vegetation and id, and the abstractions of Gregory Amenoff and Jim Waid. The expressive and poetic aspects of contemporary landscape painting—from high verisimilitude to visceral response—serve to illustrate the depth and breadth of this vein of the American landscape tradition.

NOTES

1. J.Benjamin Townsend, ed., *Charles Burchfield's Journals: The Poetry of Place* (Albany: State University of New York Press, 1993), p. 43.

Figure no. 8
Albert Pinkham Ryder American, 1847–1917
Moonlit Cove c. 1880–90
oil on canvas, 14⅛ x 17⅛ inches
The Phillips Collection, Washington, D.C.

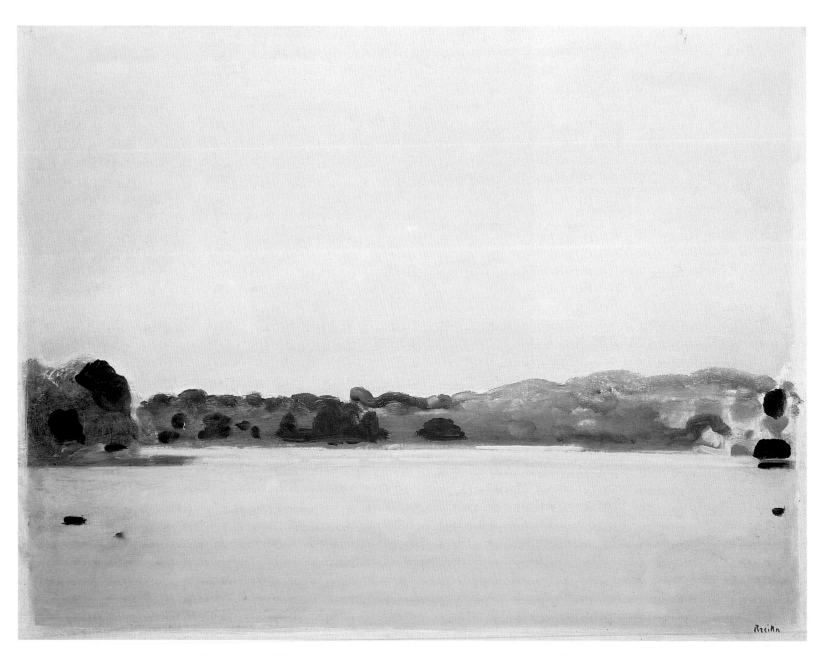

Paul Resika b. 1928 **Horse Leech Pond** 1985–88 oil on canvas 38 x 50 inches
Courtesy of Salander-O'Reilly Galleries, New York
checklist no. 73

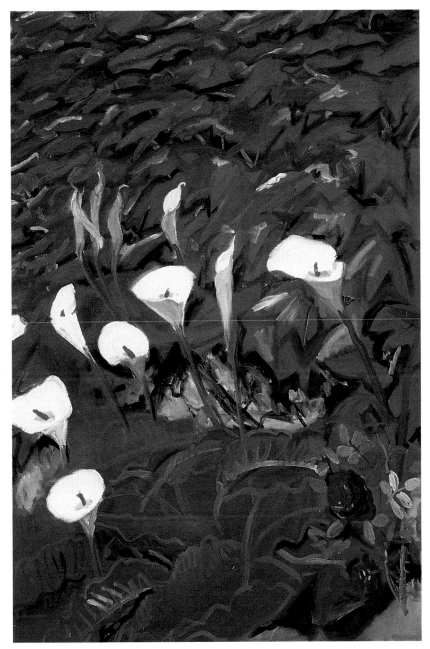

Paul Georges b. 1923 **Calla Lillies** 1994 oil on canvas 60 x 40 inches
Courtesy of Salander-O'Reilly Galleries, New York
checklist no. 33

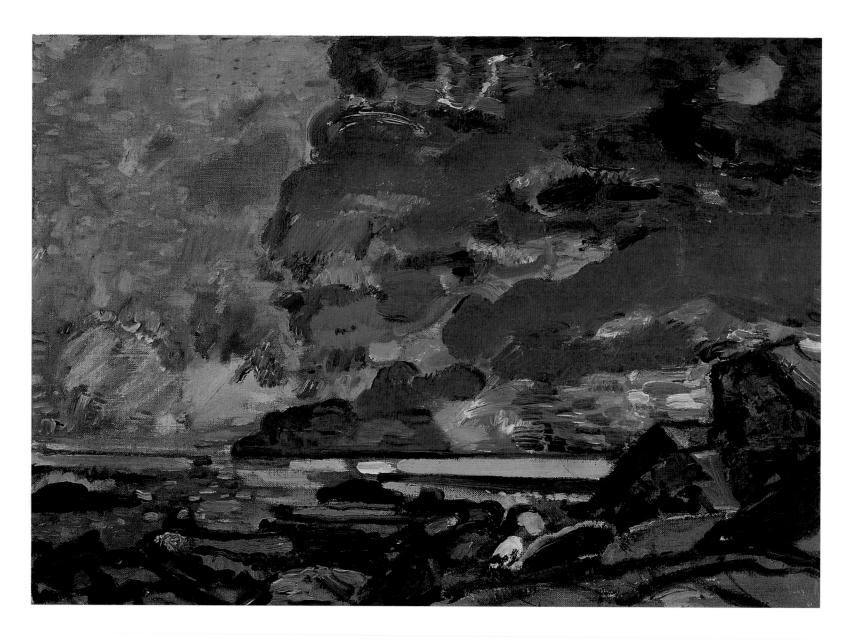

Bernard Chaet b. 1924 **Changing Light** 1992 oil on canvas 14 x 20 inches
Courtesy of Alpha Gallery, Boston, Massachusetts
checklist no. 20

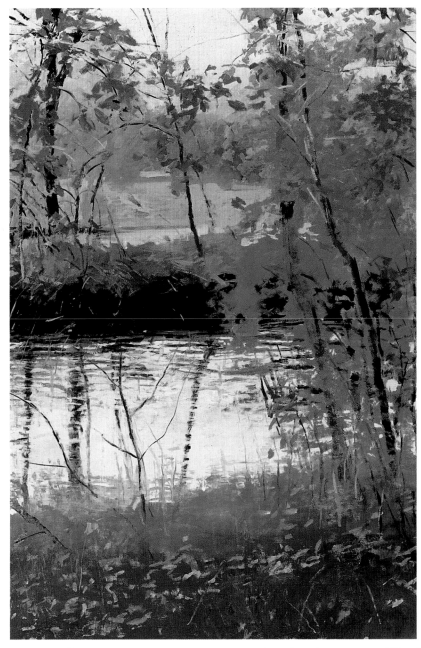

Forrest Moses b. 1934 **Slow Water at Chadd's Ford** n.d. oil on canvas 72 x 48 inches

Private collection, Santa Fe, New Mexico

checklist no. 59

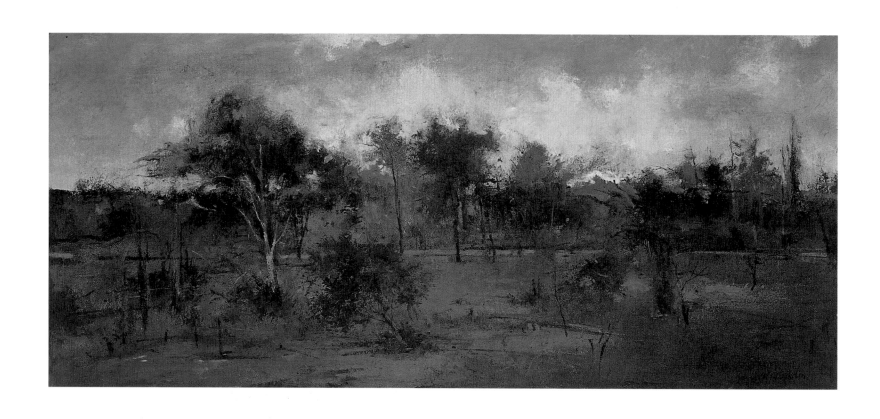

John Alexander b. 1945 **Late Summer behind the Studio** 1990 oil on canvas 22⅛ x 50⅛ inches
Courtesy of Marlborough Gallery, New York
checklist no. 1

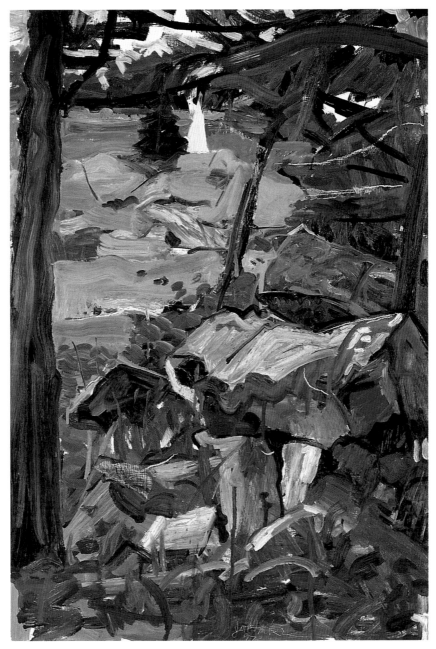

Jon Imber b. 1950 **The Ledge** 1997 oil on board 32 x 22 inches
Courtesy of Nielsen Gallery, Boston, Massachusetts
checklist no. 43

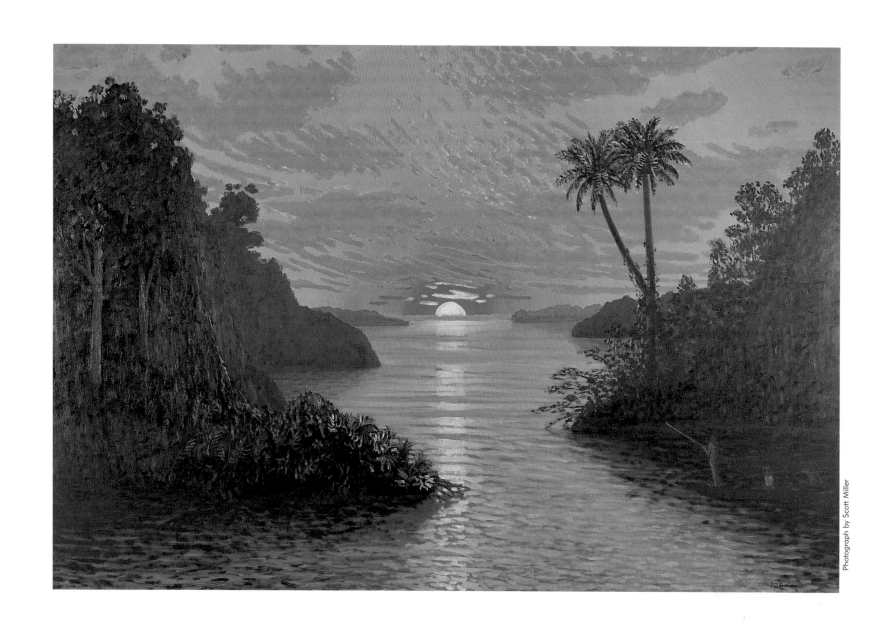

Photograph by Scott Miller

Bill Sullivan b. 1942 **La Vida** 1997 oil on canvas 40 x 60 inches

Collection of the artist

checklist no. 75

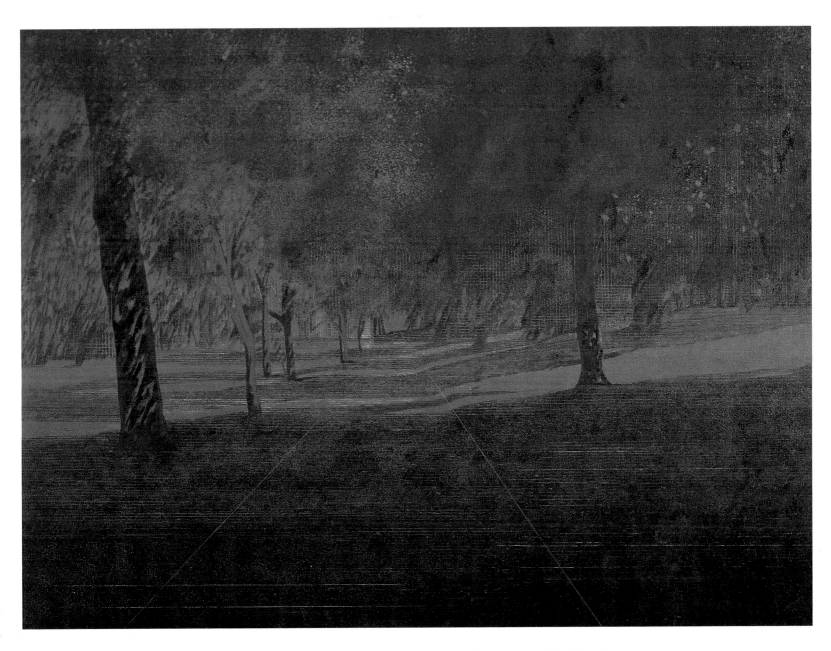

Daniel Lang b. 1935 **Quincy Light** 1985 oil on canvas 38 x 51 inches
Collection of the artist
checklist no. 50

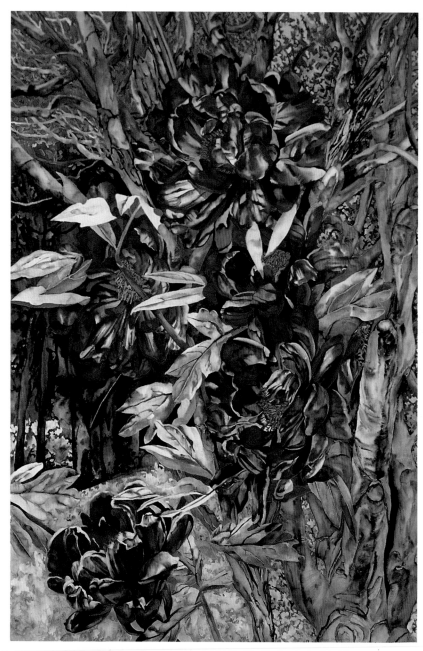

Patricia Tobacco Forrester b. 1940 **Blackest Peonies** 1995 watercolor on paper 40 x 60 inches

Courtesy of the artist

checklist no. 29

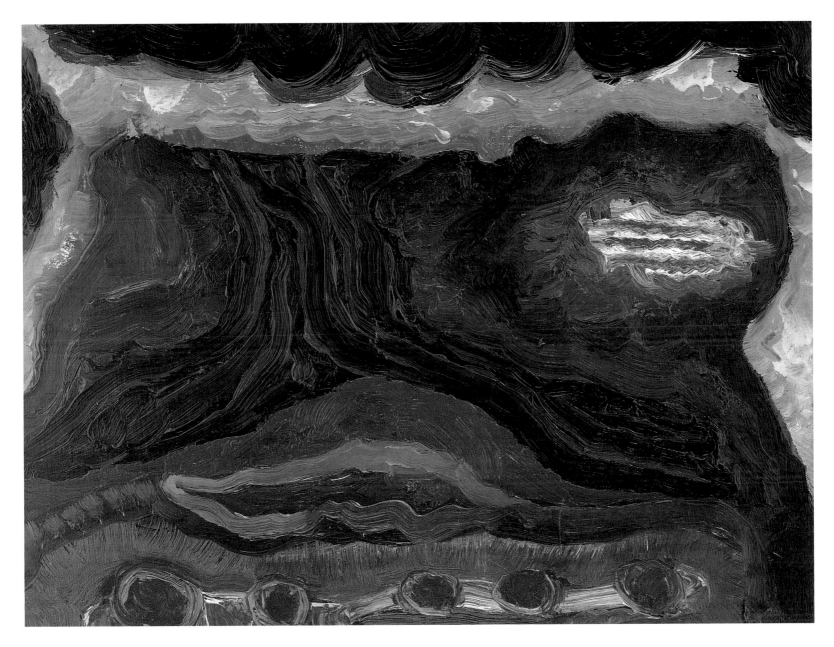

Gregory Amenoff b. 1948 **View, #36** 1998 oil on board 12 x 16 inches
Courtesy of the artist
checklist no. 4

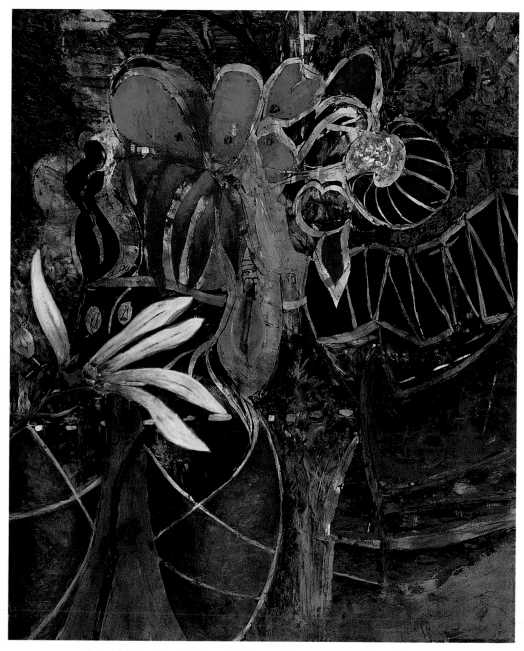

Jim Waid b. 1942 **Olla** 1997 acrylic on canvas 72 x 60 inches
Private collection. Tucson, Arizona
checklist no. 81

Richard Claude Ziemann b. 1932 **Cricklewood Pond** 1985–86 etching and engraving 11 x 14 inches

Courtesy of the artist

checklist no. 89

6

The Landscape as Fiction and Allegory

"Nature is mythical and mystical always, and spends her whole genius on the least work."

Henry David Thoreau

Fairfield Porter admired the spontaneity, vigor, and open-ended inventiveness of Abstract Expressionism, and as Rackstraw Downes points out in his introduction to Porter's reviews and criticism, *Art in Its Own Terms*, he "saw Impressionism as a revolution in favor of empiricism, which Vuillard developed and Cézanne reversed. American abstract painting in the 1940s, responding to aspects of the American situation and environment, returned to a form that relates to the Impressionist-derived art of Vuillard."[1]

Porter felt that Abstract Expressionism was an objective response to both the painter's situation and the act of painting. "For both Vuillard and the Abstract Expressionists there is no object in the sense of there being no separation of means from ends."[2] On both coasts, the realism and figurative painting that emerged in the fifties and sixties—along with Formalism and Pop Art, including the work of Robert Rauschenberg and Jasper Johns—was heavily influenced by Abstract Expressionism. Significantly, most of that generation of realists had direct contact with the Abstract Expressionists and developed deep, lasting friendships with them, a connection that is too often overlooked.

Unfortunately, almost nothing has been written about either the esthetic or procedural polarity that separates the Bay Area figurative painters from their contemporaries on the East Coast.

The most distinctive factor centers on the role of, and the emphasis placed on, direct observation. The East Coast realists worked directly from the subject or from perceptual studies and aimed toward a painterly "illusion of appearance."[3] But where Fairfield Porter, Alex Katz, Philip Pearlstein, and Lennart Anderson, for example, employed the scale, immediacy, and painterly freshness of Abstract Expressionism, the West Coast artists such as David Park, James Weeks, Theophilus Brown, Richard Diebenkorn, and Paul Wonner embraced its open-ended improvisational character and gestural vigor.

In regard to shared ground, it is notable that on both coasts, many of the painters associated with the writers and poets of the Beat Generation and were serious advocates of jazz. Larry Rivers was a professional saxophonist in a jazz band, and David Park, James Weeks, Elmer Bischoff, and others were amateur jazz musicians. *Pull My Daisy* (1959), one of the earliest underground movies, was written by Jack Kerouac, co-directed by the photographer Robert Frank and Alfred Leslie, and filmed in Leslie's loft. Allen Ginsberg, Alice Neel, the French actress Delphine Seyrig (the enigmatic woman in *Last Year at Marienbad*), and other poets and artists appeared in it. Neel recalls having been paid $25 for the day. Two years later on the West Coast, Theophilus Brown did portrait drawings of Allen Ginsberg and Jack Kerouac.[4]

In his criticism, Fairfield Porter reserved a special venom for the Bay Area painters, those whose work centered on improvisation rather than observation and often contained imagery with literary connotations. Clearly, as the following statement illustrates, he found the California painters' synthesizing and generalizing of the figure to be particularly irritating and their content either hollow or mannered:

> These paintings represent the sort of thing that for an Easterner is wrong with California. The streamlined improbable trees, like eucalyptus trees, have no character. The colors are bright and without savor. The weather is dramatic, but no one has to cope with it. Each painting is like a stage setting ready for actors who have confidence and health but no feeling.[5]

The long, illustrious career of the Bay Area painter Theophilus Brown serves to illustrate both the commonality and differences between the two groups. Significantly, this is the generation that returned to their studies after World War II. Brown, like Pearlstein, Diebenkorn, and others, studied art on the GI Bill.

Theophilus Brown is an accomplished classical pianist. He graduated from the Yale School of Music in 1941 and served in the army during World War II. Using the GI Bill, he first studied art with Amédée Ozenfant in New York and

then with Fernand Léger in Paris. When Brown returned to New York in 1950, he met Philip Guston, Willem and Elaine de Kooning, Mark Rothko, and Roberto Matta. Both de Kooning and Matta were major influences on Brown's work, and the de Koonings became close friends. In 1952 the thirty-three-year-old Brown entered the graduate painting program at the University of California at Berkeley. It was there that he met and developed a lasting friendship with Paul Wonner.

In the mid-fifties Brown did a series of football paintings that were derived from the sports pages. Porter described these and Wonner's canvases as "journalistic" and a "cavalier use of the human subject," but in doing so he actually picks up on the very characteristics that distinguish their work. Many of Brown and Wonner's images were narrative and allegorical (perhaps elusively so), and that has remained a constant for almost a half century. Brown's paintings, from his deserted backstreets and de Chirico-like industrial views to his beach figures and sunbathers borrowed from old nudist magazines, have an enigmatic, dreamlike quality that should not be confused with surrealism. His diminutive, crusty-surfaced *Sun and Moon* (checklist no. 17, p. 134), with its staring masklike face in front of an elusively protean landscape capped with a rather medieval sun and moon, is one of those enigmatic works that lingers in the memory. Ironically, the strength of this painting and

those by other Bay Area figurative artists, James McGarrell, and Peter Milton lies in the very aspects Porter so intensely disliked.

Of all the Bay Area artists, Richard Diebenkorn is the most widely known and admired. If there is a consistent thread that runs through Diebenkorn's diverse oeuvre, it is the instinctive eloquence of his line, the tautness of his composition, and his uncanny sense of color, balance, and proportion. Although they are usually untitled, his paintings—from the early *Sausalito* abstractions and the figurative works through the *Ocean Park* (checklist no. 25, p. 135) canvases and works on paper to the last small *Healdsburg* gouaches—have always been identified by the painter's specific location. Diebenkorn's ever-shifting cat's cradle of verticals and diagonals, rather than being topographically descriptive, may have its genesis in an opened transom or its hardware, the cool afternoon shadow raking across a stucco wall, the blue of the Pacific, or the sink and cabinet in his studio. A beautiful group of eight acrylics on paper, for example, evolved from aerial photographs of the Salt River and irrigation trenches in Colorado. They were done in 1970 for an exhibition sponsored by the U.S. Department of the Interior's Bureau of Reclamation, but have apparently disappeared in the bureaucratic bowels of that agency.

Whereas Porter's painterly realism has roots in

perceptual transcription as practiced by Vuillard, the metamorphic evolution of Diebenkorn's figurative paintings and *Ocean Park* abstractions reflects his deep admiration and affinity for Matisse. The palimpsest of rejected moves lying beneath the translucent layers of color in his canvases and graphics—traces of evidence that both Clement Greenberg[6] and Fairfield Porter found to be so objectionable—has documented precedence in Matisse's *Large Reclining Nude* (1935), *Woman in Blue* (1937), and many of his major drawings and cutouts, such as *Nymph and Faun with Pipes* (ca.1942–43) and *Blue Nude, IV* (1952).

The *Ocean Park* abstractions, which overlapped his figurative works and continued until the Diebenkorns moved from Santa Monica to Healdsburg in 1988, have frequently been described as landscapes, but the various series, including the figurative paintings, could be more accurately described as a referential response to place. Like de Kooning's *Long Island* paintings, they insist on a broader definition of landscape.

Many of Wayne Thiebaud's classic works from the sixties—*Salad, Sandwiches and Dessert* and *Gumball Machine*, for example—were painted from memory. But he follows no set procedure. Some of the paintings, drawings, and prints, such as those images of steep, improbable hills and precariously balanced

buildings depicted in his San Francisco cityscapes, have a factual basis but careen off into fiction. Others, including his portraits, figure drawings, and many of the still lifes, are rendered from the object. In addition, Thiebaud has painted numerous plein air views. His more recent landscapes are loosely based on the fertile floodplain of the Sacramento River Delta. Like his urban paintings, they touch on visual fact and then tilt into views that simultaneously refer to a diverse inventory of historical and esthetic precedents (such as Diebenkorn's taut vectors) and a generous sampling of Thiebaud's own inventory. With the waterway as a recurrent thread, *Bright River* (checklist no. 78, p. 136) and the other recent landscapes can best be understood as an ongoing series, art historical homages, and personal reminiscences. Their tilted, improbable perspectives recall Hokusai's *One Hundred Views of Mount Fuji* and Hiroshige's *Fifty-Three Stations of the Tōkaidō* (figure 9, p. 124), perhaps as transliterated by George Herriman.

The seductive lure of Japanese woodcuts—from their dramatic impact on the Impressionists, Frank Lloyd Wright, Kolo Moser, Greene and Greene, Bruce Goff, and other painters, architects, and designers to contemporary artists such as Thiebaud, Paul Wonner, Jack Beal, and Alfred Leslie—continues to be an understated influence. Nowhere is this more clear than in *Twenty-Seven Studies for*

Romantic Views of San Francisco by Paul Wonner and the series of monochromatic watercolors, *100 Views Along the Road*, by Alfred Leslie.

Paul Wonner and Wayne Thiebaud were both born in 1920. Wonner, like Theophilus Brown, is one of the major Bay Area figurative painters. His work has moved from the vigorous, gestural painting that typified that group to a more tightly rendered form of figuration. Today, he is best known for his elaborate, lushly colored still life paintings, which form a long and ongoing homage to the Dutch flower paintings and *pronks* (ostentatious objects) of the Golden Age. Like the Dutch precedents, the individual objects in Wonner's compositions are painted from life, but the interior or exterior spaces and the placement of objects are improvisations. Most have gone through numerous alterations before they were completed.

The various *Romantic Views* could perhaps be described as plein air studies, in that they are aspects of San Francisco that Wonner had observed during his daily run, but they were painted from memory upon his return to the studio. Each, like *No. 13, Blue and Gold Dawn* (checklist no. 87, p. 137), reflects a very different mood and character of the city across the bay. Unfortunately, the series of twenty-seven (and a subsequent group) has never been shown or reproduced in its entirety.

As a means of support, almost all of these painters had occupations other than their chosen avocation. Wayne Thiebaud was a cartoonist and commercial artist. Wonner worked as librarian at Berkeley. Diebenkorn was on the faculties of art schools and universities, and most of the Bay Area painters taught part time. In the late fifties Elmer Bischoff and James Weeks shared a studio and worked for Railway Express, a forerunner of United Parcel Service and Federal Express.

Figure no. 9
Andō Hiroshige Japanese, 1797–1858
Pine Road at Yoshiwara, Fifty-Three Stages of the Tōkaidō Road 1834
The Philbrook Museum of Art, Tulsa, Oklahoma.

After his stint at Railway Express, James Weeks painted highly detailed, photorealistic billboards for an advertising company. In the late sixties he sat in on drawing sessions with Bischoff, Diebenkorn, Brown, and others, and there are drawings and paintings of an old wash sink and storage shelves of the studio by both Diebenkorn and Weeks.

Weeks' father was a well-known bandleader and his mother was a classical pianist. As a result, he was involved with music throughout his career, and many of his major canvases center on chamber musicians and jazz groups. However, landscape painting was probably more important to him than to any of the other Bay Area figurative painters. Like Diebenkorn, Wonner, and Brown, his procedure was to do drawings from the model or in plein air and base his studio compositions on them. The broad, vigorous rendering, reductive shapes, and economical description, typified by *Sonoma Landscape* (checklist no. 83, p. 138), bely the enormous struggle, the continual reworking and adjusting that lie below the final surface of paint. Weeks worked on many of his major compositions for years.

From his early Abstract Expressionist paintings and collages through the monumental figurative paintings and landscapes, Alfred Leslie's work has consistently carried narrative and allegorical connotations. In 1972, when many museums had sold off their nineteenth-century American landscapes—the works of Frederic Church, Albert Bierstadt, Thomas Moran, and others—considering them too quaint and of little artistic merit, Leslie completed his monumental *View of the Connecticut River as Seen from Mount Holyoke* (figure no. 10). This painting was an unabashed homage to Thomas Cole's Jacksonian *View from Mount Holyoke, Northampton, Massachusetts, after a Thunderstorm—The Oxbow* (figure no. 11, p. 126). Many facets of Leslie's esthetic past converge in *100 Views*. His earlier involvement

Figure no. 10
Alfred Leslie American, b. 1927
View of the Connecticut River as Seen from Mount Holyoke 1971–72
Oil on canvas, 72 x 108 inches
Neue Galerie Ludwig Collection, Aachen, Germany

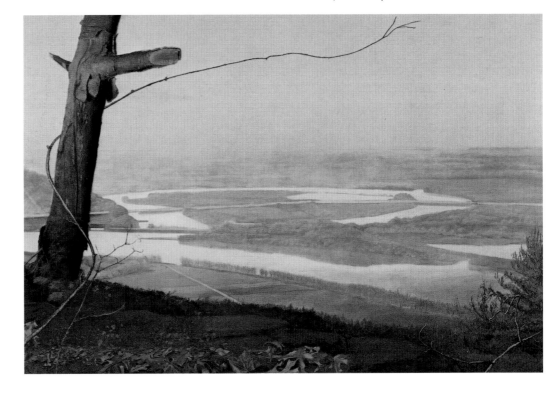

Figure no. 11
Thomas Cole American, 1801–1848
**View from Mount Holyoke,
Northampton, Massachusetts, after
a Thunderstorm—The Oxbow**
Oil on canvas, 51½ x 76 inches
The Metropolitan Museum of Art,
gift of Mrs. Russell Sage, 1908

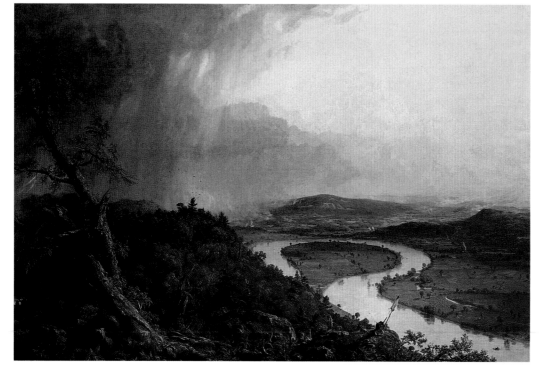

with photography and film, especially in the sequential groupings, narrative editing, and noirish light and dark, is obvious. In *Snow Drifting over Old Road Cuts, New London, Connecticut* (checklist no. 51, p. 139), the references to Abstract Expressionism are reflected in the wet fluidity of watercolor, the abstract composition, and the emphatic acknowledgment of the paper's planar surface through the blank white strips at the bottom. But the core impulse—from Leslie's utilization of monochrome, his descriptive use of the Japanese term *notan* (roughly equivalent to chiaroscuro), the repeated references to time and weather, and the title of the series—emphatically asserts the connection to the *Views* by Hiroshige and Hokusai.

Jack Beal has long acknowledged his admiration for ukiyo-e, particularly the prints of Hokusai, and this is clearly reflected in his taut, abstract compositions. For more than three decades, much of Beal's work has centered on narrative and allegory. Also, a deeply personal autobiographical thread runs through his paintings, drawings, and prints, from the various self-portraits to the nudes of his wife, Sandra, to the furniture and flea-market finds that fill his numerous still lifes. For the Bicentennial exhibition *America 1976*, Beal traveled across his home state of Virginia making drawings and shooting photographs. From the accumulated material he produced a group of six large pastel landscapes and a still life. The subjects range from Washington's vegetable garden at Mount Vernon to the Peaks of Otter. All are rendered on a middle-toned gray paper. *Chincoteague Refuge* (checklist no. 11, p. 140), with its multicolored linear embroidery of water receding to a ragged silhouette of trees against the evening sky, is the most beautiful and enigmatic of the series. The highly abstract rendering clearly indicates Beal's infatuation with Japanese prints and screens.

Both James McGarrell and Peter Milton were

born in 1930. Each has had a long, distinguished career as a printmaker, but McGarrell is better known for his paintings, and both are internationally recognized for their complex, sophisticated fictive themes, which are ripe with literary and art historical references. McGarrell has painted a series of allegorical portraits of writers, poets, and painters, including James Joyce, Vladimir Nabokov, and Henri Matisse, while Milton's etchings are loaded with images of Edgar Degas, Mary Cassatt, Marcel Duchamp, Vaslav Nijinsky, and Henry James gleaned from old photographs, paintings, and prints.

Their studio procedures, however, are quite different. Milton's rich interior compositions evolve slowly and painstakingly from studies and drawings. McGarrell starts with a colorful, spontaneously rendered abstract composition (reminiscent of late Arshile Gorky paintings) and then finds many of the anthropomorphic elements—balls, divers, forests—in the maze of Rorschachian shapes. In an interview, McGarrell stated,

> That quality of *madeness* or fabrication as opposed to descriptive replication of reality is what makes the work of art *fictive*. I construct my paintings out of the elements of my own experiences, but it's neither reality nor fantasy. Remembered perception is broken down, thoroughly reordered and synthesized into a new made thing . . . fiction.[7]

The recession of mountains and fields, scattered fires, and hot-air balloons ascending in the late afternoon light, as seen in *Ozark Valley Fog* (checklist no. 54, p. 141), is an ambiguous, dreamlike landscape improvisation that bears faint resemblance to the lush, rolling mountains of Arkansas.

The large, complex intaglios by Peter Milton have cast a spell over a literate and highly discerning segment of the American audience for more than three decades. His well-known allegorical themes, so aptly described by Rosellen Brown as "novel/poems," have long been distinguished by their formal intricacies, exquisite craft and, above all, the artist's ability to weave multilayered webs of elaborate, cinematic, and highly convincing fables. The novelist John Fowles has written,

> The sober, punctilious precision of his work almost comes as a shock after the contemporary near deification of spontaneity and its accompanying contempt for craft and skill. . . . Peter gives us "shots" of other worlds. They are not, except in their outer skins, realistic ones; but far more, mysterious and often poetic fantasies, less as prints than as novels.[8]

Milton graduated from the Yale School of Art and Architecture in 1954 and returned to its graduate program in 1960. Neil Welliver and Richard Claude Ziemann were classmates and

Bernard Chaet was their professor. In addition, Ziemann and Milton both studied printmaking with Gabor Peterdi. Milton completed Josef Albers' color courses with high marks, but in 1962 discovered that he was color-blind and decided to concentrate on graphics. Although Milton is best known for his elaborate interiors, the first five years of printmaking (1960–64) were devoted entirely to landscape etchings, and he has returned to that theme over the years. The vast, highly tactile, invented panoramic space of *Parade (second state)* (checklist no. 56, p. 142), with its procession of flag bearers, horsemen, and marching band in a distant valley, fuses the traits of Milton's earlier Bruegelesque inventions with the enigmatic narrative and poetic character of his interiors.

Don Nice has produced many life-size and overscaled paintings of buffalo, gorillas, wolves, jackrabbits, horses, bears, and a wide assortment of wildlife. These heraldic animals and birds float on a plain ground. Many of Nice's paintings, including *American Totem Alaska II* (checklist no. 63, p. 143), are composed with predelle (narrative or iconographic panels) that either flank or are located below the major image, just as they were incorporated in Renaissance altarpieces. The panels surrounding the landscape in *Alaska II* contain a bear, a squirrel, a robin, and a field of flag-like stars. In a panel running across the bottom are binoculars, a canteen, bells, and indigenous wildflowers. In this watercolor and other Nice paintings the predelle subjects either relate contextually to the main panel, such as the Alaskan landscape, subtly modify its connotations, or carry autobiographical overtones.

The Oxbow, after Church, after Cole, Flooded, 1979–1994 (checklist no. 39, p. 144), by Stephen Hannock, returns to Thomas Cole and American Luminism through Leslie's painting of the Oxbow. Hannock grew up in the Northampton area, attended Smith College, and was Leonard Baskin's apprentice until 1975. He considered professional hockey, played in the World Frisbee Championships, and is one of the few serious artists who has created phosphorescent blacklight images. His dark, gloaming versions of the Oxbow are filled with diarist notations that lie hidden in rich, dark tones of the repeatedly sanded and polished surface of the paintings. These messages record a mixture of Hannock's personal experiences on the Connecticut River and his musings about art, which give his paintings a more autobiographical character than we find in their nineteenth-century counterparts. Hannock won an Academy Award in 1998 for his paintings of heaven for the movie *What Dreams May Come*. These images, based on Luminist landscapes and allegories such as Cole's *Course of Empire* and *Voyage of Life*, were digitally converted to dramatic three-dimensional vistas.

Like Stephen Hannock, James Winn carries on the poetics of Frederic Church, Martin Johnson Heade, George Blakelock, and George Inness. Their paintings pay homage to our landscape tradition through the context of our time.

Before studying with Harold Gregor at Illinois State University, Winn lived for several years on a farm in Finland. In 1980, at Gregor's urging, he traveled to Washington, D.C., to see the *American Light* exhibition at the National Gallery. This revelatory experience, coupled with Winn's admiration for nineteenth-century Scandinavian and Russian landscape painting, converged with his familiarity with the fertile farmlands of Illinois and his deeply religious character. The specific mood of Winn's *Clearing Off: No. 6* (checklist no. 86, p. 145)—the transient weather, late afternoon light, humid haze, and quietude—is reinforced by his immense skills as a painter, but it is the spiritual aspect that imbues his work with such a strong affinity for Luminism and the Emersonian concept of "God in nature."

In quite a different vein, David Ligare has turned to the classical themes of ancient Greece and Rome, which are rendered with the pictorial lucidity and serene balance of Nicolas Poussin. Regarding these ideals, Ligare has written,

> There has been a widespread mistrust of classicism in the late twentieth century. It is believed by many to represent authoritarian or elitist ideals. In fact, the opposite is true. The new ideal that I propose is based on the classical model that is best represented by Doryphorous. It includes the integration of diversity, virtuous community participation, reverence for nature, the radical pursuit of knowledge, and the embracing of the full implications of humanist beauty.[9]

Ligare's timeless allegories with their moral connotations are set amid the beautiful rolling mountains and rocky coast of Monterey County. *Landscape for Baucis and Philemon* (checklist no. 52, p. 146) is based on the Roman poet Ovid's *Metamorphoses* and refers to his parable of hospitality. The two entwined trees on the right represent the transformation of Baucis and Philemon in death, the embracing oak and linden symbolizing love, generosity, and graciousness.

The enigmatic interiors, still lifes, and landscapes by Gillian Pederson-Krag frequently contain references to theater, music, and the arts, and all have the quality of reminiscences, reflections, or daydreams. They are much closer to poetry than to literal or fictive incidents. *Sunset (Grey and Orange)* (checklist no. 68, p. 147) and her other landscapes, with their distant shores and dramatic skies, have an odd, whimsical quality, and like her figurative works, they seem more connected to

reverie than to the specifics of time and place.

While this aspect of contemporary landscape painting—with its precedence in the allegorical images of Pieter Bruegel, the fictional topography of Jacob Ruysdael, the solemn myths of Otto Runge, the early paintings of Samuel Palmer, the late nineteenth-century poetics of George Inness, and the reveries of Albert Pinkham Ryder—has received very little discussion, it is one of major significance.

The landscape apparition *East of Long Road* (checklist no. 14, p. 148) by Debra Bermingham is rendered in a meticulous but understated manner using a subtle, muted palette and silvery light that recalls the Scandinavian interiors of Vilhelm Hammershøi. Bridget Moore has accurately and concisely stated, "Her paintings become talismans—magical images, mystery suspended in stillness. The artist accomplishes all of this with an undeterred artistic and intellectual vigor, creating works which are infinitely sustaining."[10]

Of this particular group of younger allegorical artists, April Gornik, Mark Innerst, and Joan Nelson have received the most critical attention.

Gornik has stated, "I dream in landscape images, so it seems to be an essential part of my subconscious vocabulary for emotional expression."[11] Her cryptic paintings and drawings, such as *Islands* (checklist no. 34, p. 149), are begun from small drawings and photographs, but are often drastically altered to emphasize their psychological content. They are disconcerting in the lack of a key to their scale or clue to their place. While her paintings, drawings, and prints frequently imply an ominous event such as a flood or fire, above all, they allude to mood.

Mark Innerst's paintings are based on plein air studies, photographs, and drawings. Working on hardboard panels that are laid flat rather than upright, he achieves the glassy, jewel-like colors by building up the surface with numerous transparent and translucent layers of acrylic. However, the strength of *Water Lily #10* (checklist no. 44, p. 150), which is a typical piece, lies in the delicate coupling of the abstract elusiveness of his imagery, an enigmatic narrative, and the unabashed beauty of his seductive use of the medium.

Joan Nelson's postage stamp-sized *Untitled (Evening Landscape with Shepherd, 1822: Johan Christian Dahl 1758–1857)* (checklist no. 62, p. 151) is taken from a canvas by the nineteenth-century Scandinavian artist. It differs in several ways from the earlier works by Nelson, even though they too have the look of snippets cut from antique canvases. Nelson's panel paintings were built up in stains and waxy layers with a variety of materials such as

oil, encaustic, nail polish, ink, and tinted gesso. The magical, romantic *Evening Landscape*, which is even smaller than her diminutive, unframed panels, is worked up on a toned paper with acrylics diluted to the consistency of inks.

Craig McPherson's *Kansas Landscape (Flint Hills)* (checklist no. 55, p. 152) and Chuck Forsman's *Snake Meridian* (checklist no. 30, p. 153) are derived from visual fact, but both veer off into pictorial invention. McPherson is best known for his paintings and mezzotints of Manhattan and the group of six monumental murals, *Great Harbors of the World*, commissioned by American Express for its headquarters in New York. *Kansas Landscape* differs from McPherson's urban and industrial themes in that it is based entirely on his memory of the Flint Hills and an eroded stream on his grandfather's property. He began the painting, which is best understood as reminiscence, in 1981 and has reworked it over the years. In 1998 the sky and foreground were altered considerably, bringing the composition to its present state.

Chuck Forsman studied painting with Wayne Thiebaud. Like Thiebaud's urban and river visions, Forsman's landscapes have a basis in the empirical world, but they too are fictive views. *Snake Meridian* is loosely based on black-and-white photographs of a phosphate strip mine in Utah, but the vast epic space portrayed is largely a pictorial invention loaded with minor incidents, formal devices, and visual repetitions. The rattlesnake in the lower left corner, the divided highway, the towed glider in the sky, and the car pulling a U-Haul trailer serve as narrative counterpoints and compositional repetitions. Like many of Forsman's paintings, this particular view, with its fictive undercurrents and implications of ecological disaster, conveys a multilayered allegory with the rich character of Pieter Bruegel the Elder.

The primordial acts described by Peter Allegaert and the primeval wilds depicted by David Bates and Tom Uttech, like the "green woods and crystal waters" described by Nessmuk at the close of the last century, are reminders of the awesome and complex sublimity of nature.

Allegaert gives us a sweeping aerial view of the low mountains and picturesque coast of California in *Study for Goodbye, Greenwood* (checklist no. 2, p. 154). Far below, cattle graze in the early evening light. But the scene recalls the bitter irony of Bruegel the Elder's *Fall of Icarus*, in which a tiller concentrates on the hillside furrows, a shepherd and his dog tend their flock, and a fisherman casts his line as the wingless Icarus disappears into the sea, followed by a descending flutter of feathers. Only a horrified bird notices this mythic tragedy. In *Goodbye, Greenwood*, the cows and occupants of the school bus remain obliv-

ious to the drama in the sky above them, where a screeching, terrified field mouse grips a stalk of Queen Anne's ace as a hawk carries him away.

The Texas painter David Bates is a seasoned hunter and fisherman. He has traveled up and down the Gulf of Mexico fishing and swapping tales with the Cajuns and other locals, and he is very much at home with the old, gnarled guides of the swamps and their cunning, battle-scarred dogs. Bates' paintings and sculpture reflect the expressionism of Marsden Hartley and Charles Burchfield, but they are completely devoid of those American masters' angst. Instead, his still lifes, portraits, and landscapes are filled with the wily humor, insider's wit, and pithy anecdotes that are accessible only through a long and affectionate familiarity with the subject.

Bates' earlier landscapes portray the dense everglades and wildlife of the Grassy Swamps, an area off the Red River where Texas, Louisiana, and Arkansas meet. *Red Eyes* (checklist no. 9, p. 155) depicts the swamp at dusk, teeming with wildlife in a never-ending symbiotic struggle. The rapier-billed blue herons circle the swamp on the lookout for fish, frogs, and small snakes as the red-eyed alligator rises out of the water lilies and cypress knees and attempts to make a quick meal of a great white egret. It is a parable of the fecundity and ferocity of nature.

Tom Uttech works in a similar vein and, like Bates, he is an extremely popular painter with a large following. The breadth of their public and critical appeal is reflected by the fact that both have been included in the Whitney Biennial, Uttech in 1975 and Bates in 1987. Uttech comes from a line of woodsmen and lumberjacks; he considered ornithology in college before changing his major to art. He is influenced by the nineteenth-century Scandinavian painters and feels a strong affinity for the Canadian Group of Seven. As in Bates' landscapes, Uttech's keen observations of nature are knowledgeable and deeply authentic. He differs in that he is more of a mystic. He makes no drawings or studies. Instead, his paintings are derived from his experiences in the glaciated forests and northern lakes of the Precambrian Shield, but they are studio improvisations aimed at instilling a response to the wonders of nature and reflecting its moods. He has written:

> Above all else I want my paintings to be interesting. Interest leads to curiosity and that to knowledge. Since these pictures are about nature and our role in it, the knowledge gained might grow into a love of nature, and thus into concern for its well-being. This concern could lead to action to protect nature and, therefore, ourselves.[12]

All of Uttech's titles are in Ojibwa. *Mittogami-*

Mako (checklist no. 79, p. 156) means "young bear on the river" and depicts the animal, which the painter has repeatedly given anthropomorphic and self-representational connotations,[13] standing attentively at the edge of a stream with his compact form reflected in the glassy water. Immediately beyond is an Art Nouveau-like tangle of uprooted trees and in the distance an ancient forest. The evening sky shows early traces of the northern lights. Like all of Uttech's landscapes, it is dreamlike and ripe with myth. He brings back a sense of nature as regenerative and imbued with ancient magic, and restores a quality so often lacking in Modernism—the capacity to awe and enchant.

It is significant that some of the best painting at the close of our century reflects a return to the ancient forests and allegorical woods of Thomas Cole, Frederic Church, and John James Audubon and the boundless, majestic West of George Catlin and Thomas Moran. Those artists depicted a landscape where man was not the measure, and a time when half of our continent was unmapped and untamed. Today, although most of us are acutely aware of a wide range of impending ecological disasters, very few of us have a direct, meaningful experience with nature. Perhaps these works will help lead us back.

NOTES

1. Rackstraw Downes, ed., *Fairfield Porter: Art in Its Own Terms* (New York: Taplinger Publishing Co., 1979), p. 33.

2. Ibid., p. 111.

3. Ibid., p. 103.

4. Both drawings are in the Hirshhorn Museum collection, Washington, D.C.

5. Downes, p. 195.

6. Clement Greenberg once described Diebenkorn to this writer as a "graduate school painter."

7. Jean Frumkin, *James McGarrell: Recent Paintings* (New York: Frumkin/Adams Gallery, 1991), unpaginated.

8. Fowles, quoted in Robert Flynn Johnson, *Peter Milton: Complete Prints, 1960–1996* (San Francisco: Chronicle Books, 1996) p. _____.

9. Patricia Junker, *David Ligare Paintings* (Monterey, California: Monterey Museum of Art), p. 4.

10. Bridget Moore, *Debra Bermingham* (New York: D.C. Moore Gallery, 1998), p. _____.

11. John Arthur, *Spirit of Place: Contemporary Landscape Painting and the American Tradition* (Boston: Bullfinch, 1989), p. 143.

12. Statement for exhibition announcement (Milwaukee: Tory Folliard Gallery, February 8–March 6, 1998)

13. When asked to do a self-portrait for the *New Yorker*'s exhibition listings, Uttech portrayed himself as a white bear.

Theophilus Brown b. 1919 **Sun and Moon** 1960 oil on board 9¼ x 12½ inches
Courtesy of Campbell-Thiebaud Gallery, San Francisco, California
checklist no. 17

Richard Diebenkorn 1922–1993 **Untitled** 1980 acrylic on paper 26½ x 23⁵⁄₁₆ inches
Private collection
checklist no. 25

Wayne Thiebaud b. 1920 **Bright River** 1996 oil on canvas 23¾ X 36 inches
Courtesy of Campbell-Thiebaud Gallery, San Francisco, California
checklist no. 78

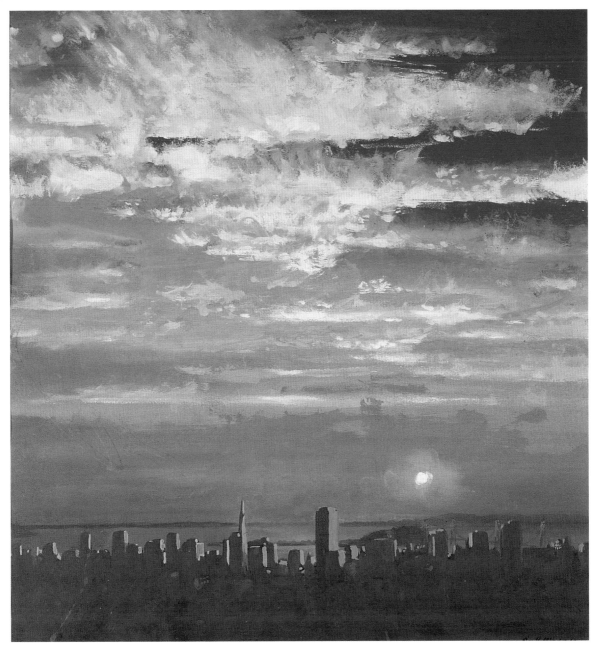

Paul Wonner b. 1920 Twenty-Seven Studies for Romantic Views of San Francisco, No. 13, Blue and Gold Dawn 1980

acrylic on paper 18 x 17 inches

Private collection

checklist no. 87

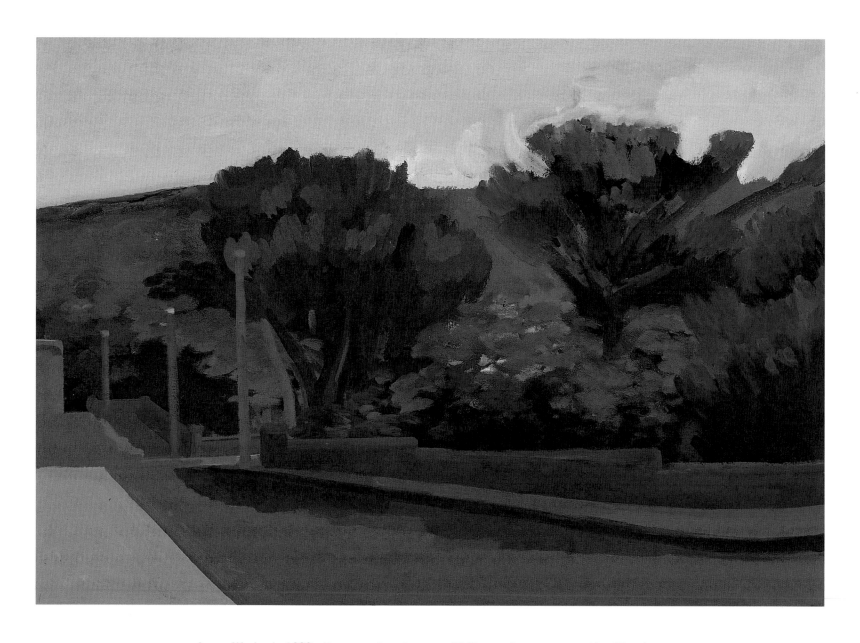

James Weeks b. 1922 **Sonoma Landscape** 1966 acrylic on canvas 40 x 57 inches

Courtesy of Campbell-Thiebaud Gallery, San Francisco, California

checklist no. 83

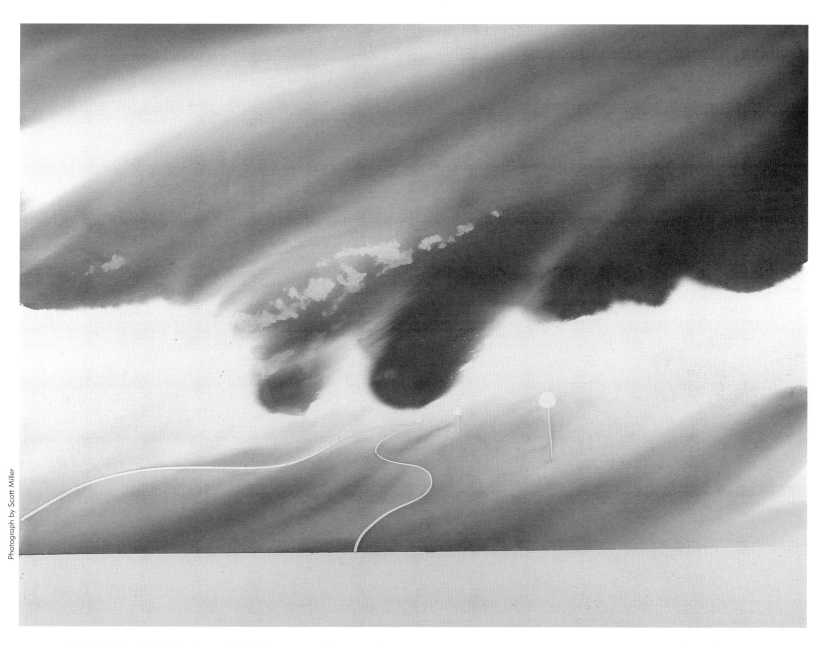

Photograph by Scott Miller

Alfred Leslie b. 1927 **Snow Drifting over Old Road Cuts, New London, Connecticut** 1983 watercolor 44 x 59 inches
Collection of the artist, courtesy of Oil & Steel Gallery, Long Island City, New York
checklist no. 51

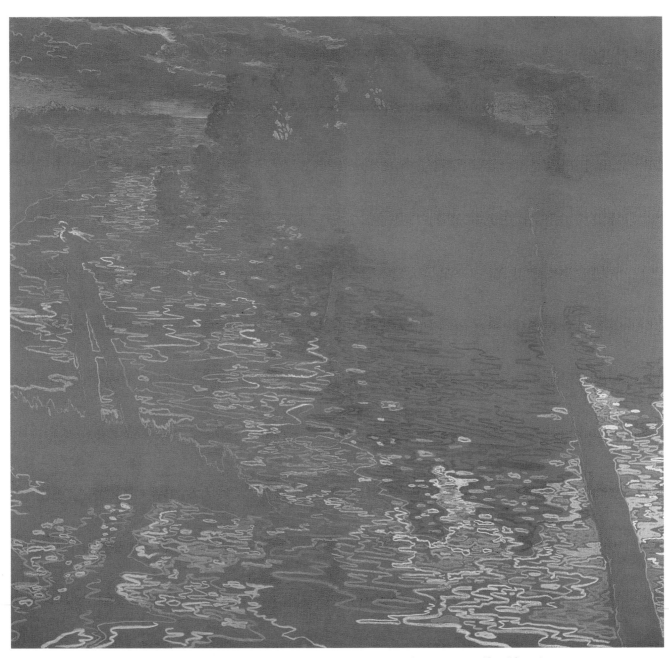

Jack Beal b. 1931 **Chincoteague Refuge** n.d. pastel on paper 48 x 52 inches

Collection of Stephen Alpert, Boston, Massachusetts

checklist no. 11

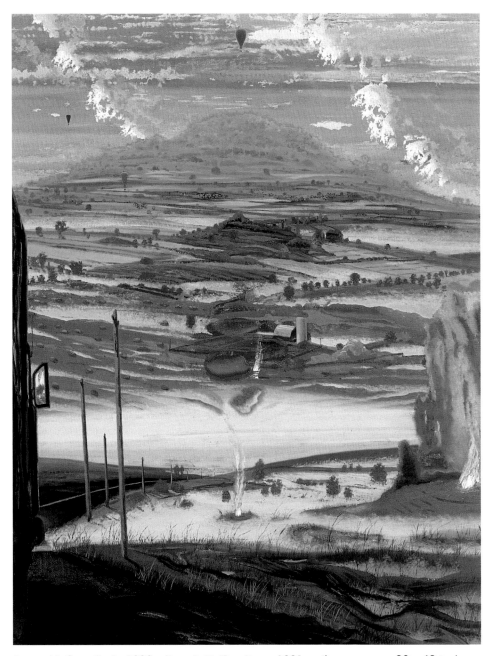

James McGarrell b. 1930 **Ozark Valley Fog** 1991 oil on canvas 80 x 62 inches
Courtesy of George Adams Gallery, New York
checklist no. 54

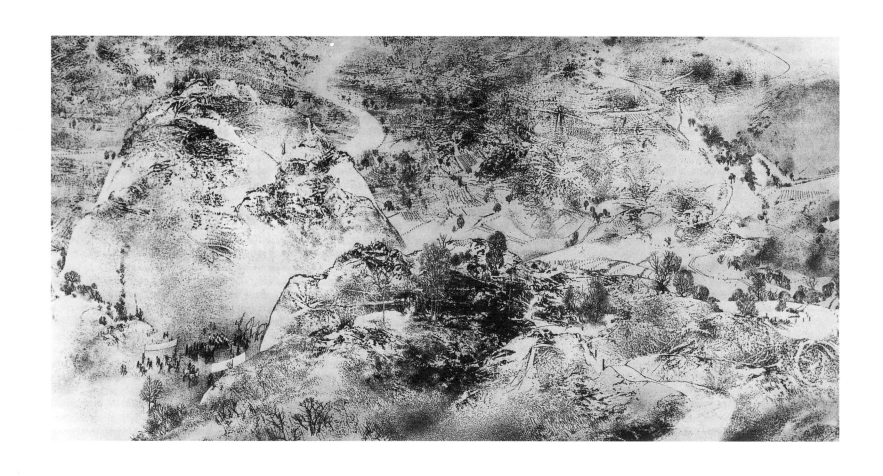

Peter Milton b. 1930 **Parade (second state)** 1966 lift-ground etching and aquatint 18 x 36 inches
Courtesy of the artist
checklist no. 56

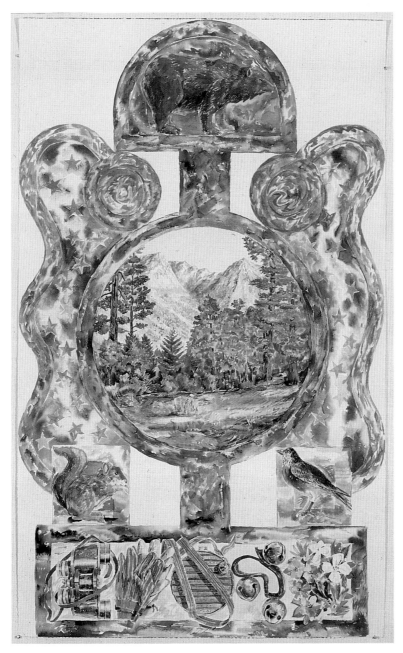

Don Nice b. 1932 **American Totem Alaska II** 1986
watercolor on paper 72½ x 44 inches
Courtesy of Babcock Galleries, New York

checklist no. 63

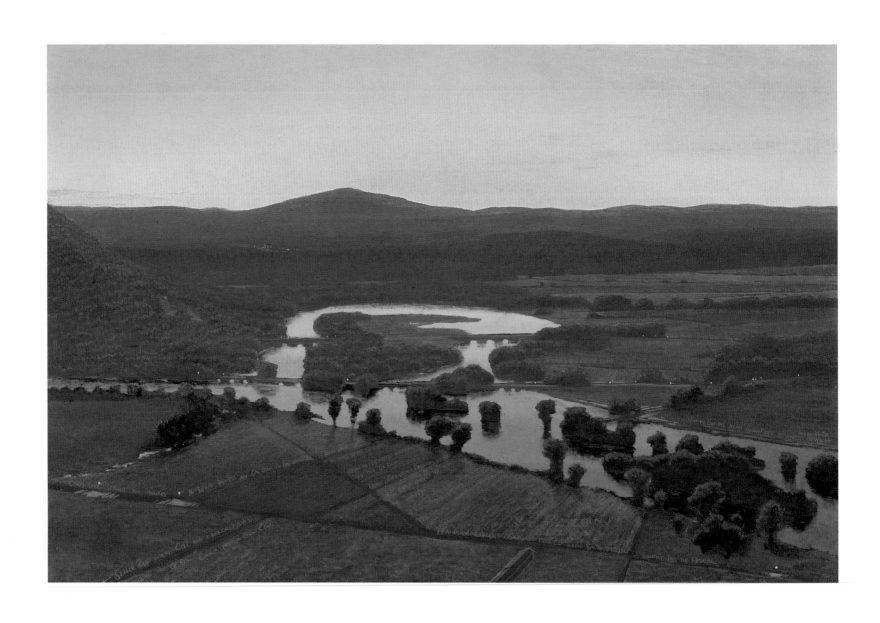

Stephen Hannock b. 1951 **The Oxbow, after Church, after Cole, Flooded, 1979–1994 (Flooded River for the Matriarchs: E. & A. Mongan) Final Study** 1994 polished oil on canvas 24 x 36 inches

Collection of the artist

checklist no. 39

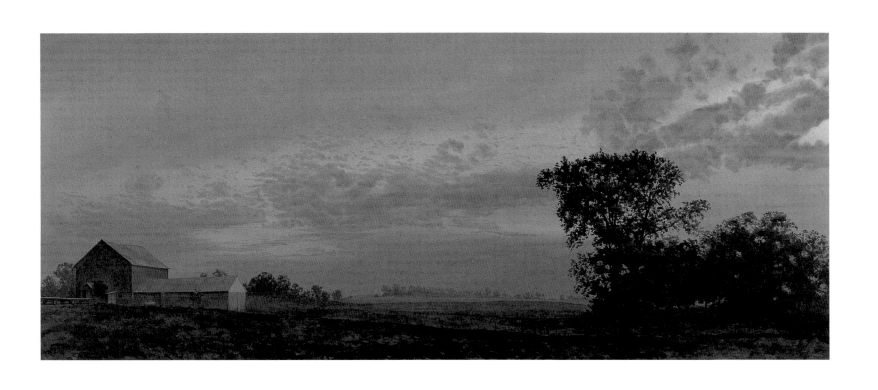

James Winn b. 1949 **Clearing Off: No. 6** 1996 acrylic on paper 18½ x 46 inches

The Philbrook Museum of Art, Tulsa, Oklahoma, museum purchase

checklist no. 86

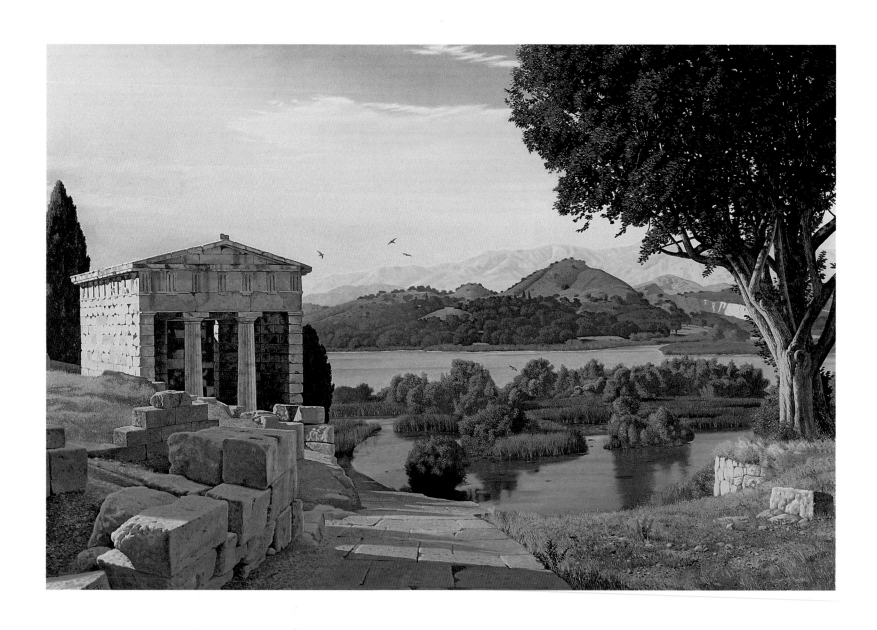

David Ligare b. 1945 **Landscape with Baucis and Philemon** 1984 oil on canvas 32 x 48 inches
The Wadsworth Antheneum, Hartford, Connecticut, the Ella Gallup Sumner and Mary Catlin Sumner Collection Fund
checklist no. 52

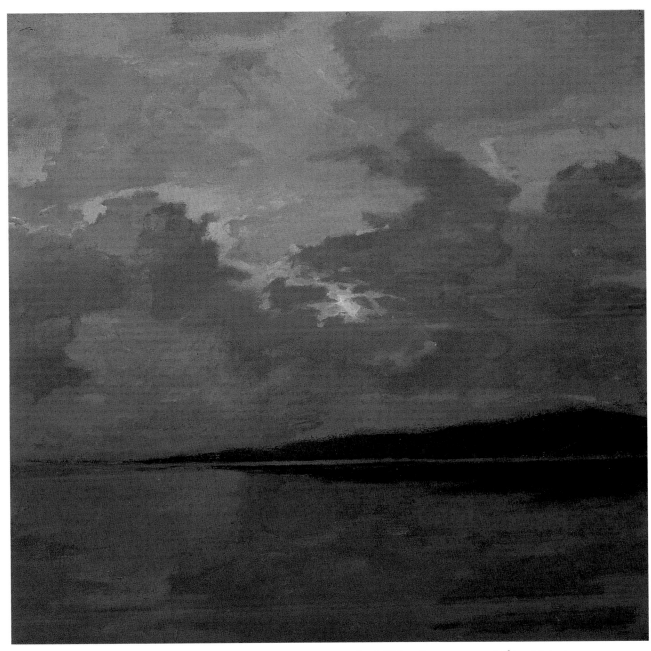

Gillian Pederson-Krag b. 1938 **Sunset (Gray and Orange)** 1994 oil on canvas 16¾ x 18 inches

Courtesy of Hackett Freedman Gallery, San Francisco, California

checklist no. 68

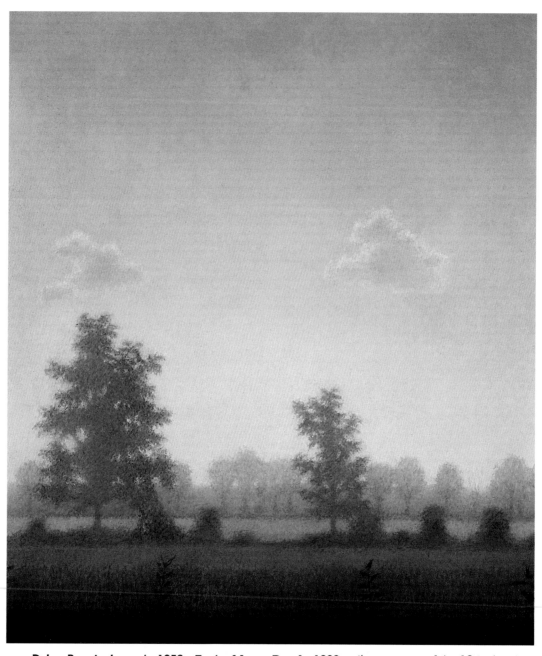

Debra Bermingham b. 1953 **East of Long Road** 1993 oil on canvas 14 x 12 inches

Collection of Edward DeLuca, courtesy of D. C. Moore Gallery, New York

checklist no. 14

April Gornik b. 1953 **Islands** 1984 charcoal and pastel 39 x 49½ inches
Smith College Museum of Art, Northampton, Massachusetts, gift of Rita Rick Fraad (Rita Rick, class of 1937)
in memory of her husband, Daniel J. Fraad Jr.,1991

checklist no. 34

Mark Innerst b. 1957 **Water Lily #10** 1990 acrylic on board with hand-built frame 19½ x 29¾ inches

Courtesy of D. C. Moore Gallery, New York

checklist no. 44

Joan Nelson b. 1958 **Untitled (Evening Landscape with Shepherd 1822: Johan Christian Dahl 1758–1857)** 1997
acrylic ink on paper 2⅛ x 2⅝ inches (shown actual size)
Courtesy of Robert Miller Gallery, New York
checklist no. 62

Craig McPherson b. 1948 **Kansas Landscape (Flint Hills)** 1998 oil on canvas 48 x 54 inches
Collection of the artist
checklist no. 55

Chuck Forsman b. 1944 **Snake Meridian** 1997 oil on Masonite 74 x 55 inches
Courtesy of Mr. and Mrs. Alan Greenberg
checklist no. 30

Peter Allegaert b. 1938 **Study for Goodbye, Greenwood** 1993 acrylic on paper 17½ x 33 inches
Courtesy of Campbell-Thiebaud Gallery, San Francisco, California
checklist no. 2

David Bates b. 1952 **Red Eyes** 1987 oil on canvas 78 x 96 inches

Collection of the Speed Art Museum, Louisville, Kentucky

checklist no. 9

Tom Uttech b. 1942 **Mittogami-Mako** 1990 oil on canvas 57 x 50 inches
The Philbrook Museum of Art, Tulsa, Oklahoma, museum purchase in honor of Keith E. Bailey
for his service as chairman of the board, 1994–1995

checklist no. 79

Epilogue

"Every age and every form of creative endeavor owes much to those outstanding artists whose untiring labors brought forth new meanings and new rhythms. But in the twentieth century the necessary equilibrium between tradition and the search for the new has been repeatedly upset by a falsely understood 'avant gardism'—a raucous, impatient 'avant gardism' at any cost. Dating from before World War I, this movement undertook to destroy all commonly accepted art—its forms, language, features, and properties—in its drive to build a kind of 'superart,' which would then supposedly spawn the New Life itself. It was suggested that literature should start anew 'on a blank sheet of paper.' (Indeed, some never went much beyond this stage.) Destruction, thus, became the apotheosis of this belligerent avant-gardism. It aimed to tear down the entire centuries-long cultural tradition, to break and disrupt the natural flow of artistic development by a sudden leap forward."

Aleksandr Solzhenitsyn
1993[1]

Today, Thomas Moran's *Grand Canyon of the Yellowstone* (1893–1901) is handsomely displayed in an alcove at the National Museum of American Art. It is flanked on both side walls with an impressive collection of George Catlin's portraits and paintings of the Plains Indians. It is one of the most magnificent installations of American art one will encounter in America.

The first retrospective of Thomas Moran's paintings and watercolors was organized by

the National Gallery of Art in 1997. It celebrated the 125th anniversary of the founding of Yellowstone National Park and Moran's auspicious role in the formation of our national park system. In the exhibition, *Grand Canyon of the Yellowstone* (1872), *Mountain of the Holy Cross* (1875), and *Chasm of the Colorado* (1873–74) were shown as a triptych for the first time, which was how Moran had hoped to install them at the 1876 Philadelphia Centennial Exposition. Unfortunately, Congress had refused to loan the two monumental Grand Canyon paintings, so Moran never saw the three canvases together in his lifetime.

The Moran retrospective was one of many exhibitions of nineteenth-century landscape paintings that have been organized since the Bicentennial. A list of the major projects must start with John Wilmerding's landmark survey *American Light: The Luminist Movement, 1850–1875* for the National Gallery of Art in 1980. Although it did not travel, the scholarly, handsome exhibition, like Barbara Novak's book *Nature and Culture*, instilled a strong sense of the eloquence of nineteenth-century American landscape painting. Fortunately, both Wilmerding's catalogue and Novak's book are still in print.

In 1987 the Metropolitan Museum of Art mounted *American Paradise: The World of the Hudson River School*, a beautiful and scholarly examination of the progenitors of our land-scape tradition. Two years later, all of Frederic Edwin Church's major paintings were brought together for the first time at the National Gallery of Art. Franklin Kelly, an authority on Church, curated the exhibition.

The 1991 retrospective *Albert Bierstadt: Art & Enterprise*, organized by the Brooklyn Museum, brought together a full range of his major works, along with paintings that had not been publicly exhibited in this century. Three years later the National Museum of American Art assembled a major Thomas Cole exhibition. This was the largest collection of Cole's landscapes since the memorial exhibit a few months after his death in 1848.

The prospect of such scholarly and thorough examinations of American art and artists of the nineteenth century was almost unheard-of a quarter of a century ago, but as we near the millennium the list of such extravagant and enlightening exhibits and publications is growing. The revelatory *In the Light of Italy: Corot and Early Open-Air Painting* served up a dazzling array of brilliant ninteenth-century plein air painters. Most were unknown, even to those with a great interest in landscape painting. In addition, we have been introduced to the lucidly rendered nineteenth-century landscapes of Scandinavia through several major exhibitions and publications, such as *Northern Light* and *Nordic Landscape Painting in the Nineteenth Century*. The door to the

broad array of painting beyond the highly popular realm of Impressionism has been opened, and there will continue to be an abundance of surprises.

However, missing in all of these ventures is the examination of the interrelationships of the visual arts of our time and their connections with the American, Canadian, and European art of the nineteenth century. Like MoMA's *The Natural Paradise*, Joseph Czestochowski's *The American Landscape Tradition: A Study and Gallery of Paintings* (1982) failed to acknowledge a single contemporary realist painter. The publication clung to frayed Greenbergian notions and included only abstract artists, in spite of the fact that Pearlstein, Porter, Katz, Welliver, Diebenkorn, Thiebaud, and many others were internationally recognized by that time.

More than two decades after *The Natural Paradise*, the Museum of Modern Art continues to doggedly pursue its narrow interpretation of Modernism. In an exhibition that could have served as a bookend to its earlier interpretation of American landscape painting, the recent *Objects of Desire: The Modern Still Life* examined various facets of that genre from Paul Cézanne, Henri Matisse, and Georges Braque through contemporaries such as Andy Warhol, Jasper Johns, and Claes Oldenburg, and concluded with the recent works of the photographer Cindy Sherman and

the conceptualist Wolfgang Laib. But this large exhibit (131 works by sixty-seven artists) gave no indication that Wayne Thiebaud, one of the most widely admired painters in America, had brought an aspect of still life into our time with his painterly visions of pies, pastries, and gumball machines, and there was no hint of the work of Richard Diebenkorn, Paul Wonner, Fairfield Porter, William Bailey, James Valerio, Janet Fish, or Stone Roberts. Rather than an open-minded exploration of a theme, it was a program tailored to fit a narrow esthetic agenda.

In regard to such endeavors, we should keep in mind that at the close of the last century, the leading art world opinion makers in Paris were asked to chose which contemporary artist would be held in the highest regard at the close of the next century. They were unanimous in selecting Adolphe William Bouguereau, beloved for his saccharine nudes, and Jean Louis Ernest Meissonier, a painter of monumental battle scenes of the Napoleonic campaign. All those voting in the poll would have known the work of Jean Auguste Dominique Ingres, Camille Corot, Edouard Manet, Claude Monet, Edgar Degas, Paul Cézanne, Auguste Renoir, Georges Seurat, Paul Gauguin, Henri de Toulouse-Lautrec, Auguste Rodin, Aristide Maillol, and others that are now considered to be major figures in nineteenth-century painting and sculpture and the progenitors of modern art. It is likely that a

query of our contemporary museum curators, art historians, and critics would yield similar results.

When Moran first visited Yellowstone in 1871, it was known only to the Indians, a handful of trappers, and a few other rugged souls. Although hostile and difficult to traverse, the landscape was pristine, as it had been for thousands of years. Today, because of air and land pollution, Yellowstone National Park has been added to the list of endangered land. The severity of traffic problems is that of our major cities and its valleys and mountainsides have been torn to pieces by snowmobiles. From coast to coast, our rivers and streams are polluted, the wildlife threatened, and much of the land poisoned. Winds carry acids northward, where they are dropped in the rains, and gaping holes have opened in the ozone. A hundred years ago Thomas Moran's canvases and watercolors, Catlin's directly obserrved paintings, and William Henry Jackson's photographs introduced the public to the diversity, awesomeness, and extravagance of our primal paradise. Today, our painters and photographers remind us of what we have and what we are losing. As in the past, their works express symbolically and poetically the social, philosophical, and spiritual concerns of the time. They point toward the positive while reminding us of our physical and emotional dependence on nature.

This is not a time for the arts to be too self-absorbed, nor is it a time when a narrow, heavily biased, self-serving interpretation of art history, past or recent, can be accepted. The past must be retold from a broader and more inclusive perspective. The artists must look beyond the tenets of Cézanne, Cubism, and the tattered remnants of Modernism. And ultimately, we must allow room for images of reassurance, for an art that points away from itself and again focuses on the marvels and enigmas of both nature and the human situation, which will in turn open the way for new allegories and mythologies.[2]

"Give me health and a day, and I will make the pomp of emperors ridiculous. The dawn is my Assyria; the sun-set and moon-rise my Paphos, and unimaginable realms of faerie; broad noon shall be my England of the senses and understanding; the night shall be my Germany of mystic philosophy and dreams."

Ralph Waldo Emerson[3]

NOTES

1. Aleksandr Solzhenitsyn, "How the Cult of Novelty Wrecked the 20th Century," *American Arts Quarterly* (spring 1993), p. 18.

2. John Arthur, *Spirit of Place: Contemporary Landscape Painting and the American Tradition* (Boston: Bulfinch Press, 1989), p. 155.

3. Ralph Waldo Emerson, *Nature* (San Francisco: Chandler Facsimile Editions in American Literature, 1968), pp. 12–13.

Checklist of the Exhibition

1 John Alexander b. 1945
Late Summer Behind the Studio, 1996
oil on canvas
22⅛ x 50⅛ inches
Courtesy of Marlborough Gallery,
New York

2 Peter Allegaert b. 1938
Study for Goodbye, Greenwood, 1993
acrylic on paper
17½ x 33 inches
Courtesy of Campbell-Thiebaud Gallery,
San Francisco, California

3 Adele Alsop b. 1948
Summer Pond, 1987
oil on canvas
42 x 36 inches
Collection of Remak Ramsay, New York

4 Gregory Amenoff b. 1948
*View, #36,*1998
oil on board
12 x 16 inches
Courtesy of the artist

5 Brooks Anderson b. 1957
Cathedral, 1991
oil on canvas
48 x 72 inches
The Philbrook Museum of Art, Tulsa,
Oklahoma, museum purchase in honor
of Jon R. Stuart for his service as
chairman of the board of trustees,
1997–1999

6 Lennart Anderson b. 1928
Footbridge at Topsham, Maine, 1983
oil on canvas
10⅝ x 15 inches
Courtesy of Salander-O'Reilly Galleries,
New York

7 Milton Avery 1893–1965
Hills and Sunset Sky, 1964
oil on canvas
40 x 48 inches
Milton Avery Trust, courtesy of Knoedler
& Company, New York

8 Joel Babb b. 1945
Wilkinson's Brook, 1997
oil on canvas
54 x 42 inches
Courtesy Frost Gulley Gallery, Portland,
Maine

9 David Bates b. 1952
Red Eyes, 1987
oil on canvas
78 x 96 inches
Collection of the Speed Art Museum,
Louisville, Kentucky

10 Gustave Baumann 1891–1971
Winter Corral, 1950–61
woodcut
12$\frac{3}{4}$ x 12$\frac{3}{4}$ inches
Lent by Ann Baumann

11 Jack Beal b. 1931
Chincoteaque Refuge, n.d.
pastel on paper
48 x 52 inches
Collection of Stephen Alpert, Boston,
Massachusetts

12 William Beckman b. 1942
Parshall's Barn, 1977
oil on canvas
63 x 72 inches
Collection of Malcolm Holzman

13 Robert Berlind b. 1938
Delaware II, 1997
oil on board
12 x 24 inches
Courtesy of Tibor de Nagy Gallery,
New York

14 Debra Bermingham b. 1953
East of Long Road, 1993
oil on canvas
14 x 12 inches
Collection of Edward DeLuca, courtesy
of D.C. Moore Gallery, New York

15 Nell Blaine 1922–1996
First Lyme Landscape, 1973
oil on canvas
27$\frac{1}{2}$ x 36$\frac{1}{4}$
The Springfield Art Museum,
Springfield, Missouri

16 Carolyn Brady b. 1937
Red and White Parrot Tulips Unfolding,
1987
watercolor on paper
18$\frac{1}{4}$ x 23$\frac{3}{4}$ inches
Farnsworth Art Museum, Rockland,
Maine, gift of the artist, 1987

17 Theophilus Brown b. 1919
Sun and Moon, 1960
oil on board
9$\frac{1}{4}$ x 12$\frac{1}{2}$ inches
Courtesy of Campbell-Thiebaud Gallery,
San Francisco, California

18 Charles Burchfield 1893–1967
Late Winter Radiance, 1961–62
watercolor on paper
44 x 26$\frac{1}{2}$ inches
The Butler Institute of American Art,
Youngstown, Ohio, museum purchase,
1962

19 James Butler b. 1945
Landscape with Pond, 1984
pastel on paper
30 x 42 inches
Collection of Stephen Alpert, Boston,
Massachusetts

20 Bernard Chaet b. 1924
Changing Light, 1992
oil on canvas
14 x 20 inches
Courtesy of Alpha Gallery, Boston,
Massachusetts

21 Larry Cohen b. 1952
California Incline, n.d.
oil on canvas
40 x 40 inches
Collection of Terry and Eva Herndon

22 Gordon Cook 1927–1985
Delta Moonlight Scene, n.d.
oil on canvas
14 x 16 inches
Courtesy of Schmidt-Bingham Gallery,
New York

23 Richard Crozier b. 1944
Sycamore at Sugar Hollow, 1997
oil on Masonite
24 x 32 inches
Courtesy of Tatistcheff Gallery, New York

24 Edwin Dickinson 1891–1978
Rock, Cape Poge, 1950
oil on canvas
11½ x 14¼ inches
Collection of Mr. and Mrs. Daniel W.
Dietrich II, Chester Springs, Pennsylvania

25 Richard Diebenkorn 1922–1993
Untitled, 1980
acrylic on paper
26½ x 23⁵⁄₁₆ inches
Private collection

26 Rackstraw Downes b. 1939
*Rainwater Ditch and Six Culvert Bridge,
Texas City, Texas*, 1996
oil on canvas
19 x 90 inches
The Philbrook Museum of Art, Tulsa,
Oklahoma, museum purchase

27 Joellyn Duesberry b. 1944
Winter Streambed, 1989
oil on linen
40 x 30 inches
Collection of the artist, Denver, Colorado

28 Richard Estes b. 1932
Melitus, 1999
oil on canvas
35 x 60 inches
Lent by the artist, courtesy of
Marlborough Gallery, New York

29 Patricia Tobacco Forrester b. 1940
Blackest Peonies, 1995
watercolor on paper
60 x 40 inches
Courtesy of the artist

30 Chuck Forsman b. 1944
Snake Meridian, 1997
oil on Masonite
74 x 55 inches
Courtesy of Mr. and Mrs. Alan Greenberg

31 Jane Freilicher b. 1924
Cherry Blossoms Painted Outdoors, 1977
oil on canvas
36 x 36 inches
The Currier Gallery of Art, Manchester,
New Hampshire, gift of Howard and
Beverly Zagar

32 Sheila Gardner b. 1933
From Twin to Alice, 1997
oil on canvas
50 x 60 inches
Courtesy of Gail Severn Gallery,
Ketchum, Idaho

33 Paul Georges b. 1923
Calla Lilies, 1994
oil on canvas
60 x 40 inches
Courtesy of Salander-O'Reilly Galleries,
New York

34 April Gornik b. 1953
Islands, 1984
charcoal and pastel
39 x 49½ inches
Smith College Museum of Art,
Northampton, Massachusetts, gift of
Rita Rick Fraad (Rita Rick, class of 1937)
in memory of her husband, Daniel J.
Fraad Jr.,1991

35 Harold Gregor b. 1929
Illinois Landscape #124, 1993
oil and acrylic on canvas
82 x 60 inches
Courtesy of Elliot Smith Contemporary
Art, Saint Louis, Missouri

36 Margaret Grimes b. 1943
Study for the Woods at Night, 1991
oil on canvas
40 x 40 inches
Courtesy of Blue Mountain Gallery,
New York

37 Simon Gunning b. 1956
Krenkel's Pond, 1990
oil on canvas
20 x 22 inches
Courtesy of Galarie Simonne Stern,
New Orleans, Louisiana

38 Woody Gwyn b. 1944
Interstate Roadcut, 1996
mixed media on panel
22 x 22 inches
Courtesy of Gwyn and Gwyn Arts, Ltd.

39 Stephen Hannock b. 1951
*The Oxbow, after Church, after Cole,
Flooded, 1979–1994 (Flooded River for
the Matriarchs: E. & A. Mongan) Final
Study*, 1994
polished oil on canvas
24 x 36 inches
Collection of the artist

40 Alexandre Hogue 1898–1994
Lava-Capped Mesa, Big Bend, 1976
oil on canvas
34 x 56 inches
University of Tulsa

41 Peter Holbrook b. 1940
Nightfall—Harris Beach, 1992
oil and acrylic on paper
31 x 40 inches
Courtesy of the artist

42 Edward Hopper 1882–1967
Cape Cod Bay, 1965
watercolor on paper
22$\frac{1}{8}$ x 29$\frac{7}{8}$ inches
Whitney Museum of American Art,
New York, Josephine N. Hopper Bequest

43 Jon Imber b. 1950
The Ledge, 1997
oil on board
32 x 22 inches
Courtesy of Nielsen Gallery, Boston,
Massachusetts

44 Mark Innerst b. 1957
Water Lily #10, 1997
acrylic on board with hand-built frame
19$\frac{1}{2}$ x 29$\frac{3}{4}$ inches
Courtesy of D. C. Moore Gallery,
New York

45 Keith Jacobshagen b. 1941
Tractor Road-edge of Salt Valley, 1987
oil on paper
8$\frac{1}{2}$ x 18$\frac{1}{4}$ inches
The Philbrook Museum of Art, Tulsa,
Oklahoma, gift of Thomas E. Matson
and Joe Marina Motors

46 Yvonne Jacquette b. 1934
Double Wing Sunset, 1995
pastel
19$\frac{3}{8}$ x 14$\frac{1}{4}$ inches
Private collection, courtesy of
D. C. Moore Gallery, New York

47 Wolf Kahn b. 1927
Rhapsody In Yellow, 1997
oil on canvas
70 x 90 inches
Courtesy of Beadleston Gallery, New York

48 Alex Katz b. 1927
Untitled (Shore Scene), 1956
oil on board
16 x 24 inches
Courtesy of Robert Miller Gallery,
New York

49 Rockwell Kent 1882–1971
Village at Night, c. 1950
oil on panel
12 x 16 inches
Collection of Remak Ramsay, New York

50 Daniel Lang b. 1935
Quincy Light, 1985
oil on canvas
38 x 51 inches
Collection of the artist

51 Alfred Leslie b. 1927
*Snow Drifting over Old Road Cuts,
New London, Connecticut*, 1983
watercolor
44 x 59 inches
Collection of the artist, courtesy of Oil &
Steel Gallery, Long Island City, New York

52 David Ligare b. 1945
Landscape for Baucis and Philemon,
1984
oil on canvas
32 x 48 inches
The Wadsworth Antheneum, Hartford,
Connecticut, the Ella Gallup Sumner and
Mary Catlin Sumner Collection Fund

53 Ann Lofquist b. 1964
Three Trees In November, 1995
oil on linen
31 x 60 inches
Courtesy of Tatistcheff Gallery, New York

54 James McGarrell b. 1930
Ozark Valley Fog, 1991
oil on canvas
80 x 62 inches
Courtesy of George Adams Gallery,
New York

55 Craig McPherson b. 1948
Kansas Landscape (Flint Hills),
1981–1998
oil on canvas
48 x 54 inches
Collection of the artist

56 Peter Milton b. 1930
Parade (second state), 1966
lift-ground etching and aquatint
18 x 36 inches
Courtesy of the artist

57 John Moore b. 1941
Summer Evening, 1993
oil on board
24 x 24 inches
Collection of Frank and Sharon Boltrom,
Monroe, Maine

58 Daniel Morper b. 1944
The Last Signal, 1998
oil on canvas
24 x 30 inches
Courtesy of Tatitscheff Gallery, New York

59 Forrest Moses b. 1934
Slow Water at Chadd's Ford, n.d.
oil on canvas
72 x 48 inches
Private collection, Santa Fe, New Mexico

60 Catherine Murphy b. 1946
Driveway onto East Dorsey Lane, 1988
oil on canvas
44 x 58 inches
Courtesy of Lennon, Weinberg Gallery,
New York

61 Alice Neel 1900–1984
Sunset, Riverside Drive, 1957
oil on canvas
50 x 26 inches
Estate of Alice Neel, courtesy of Robert
Miller Gallery, New York

62 Joan Nelson b. 1958
*Untitled (Evening Landscape With
Shepherd 1822: Johan Christian Dahl
1758–1857)*, 1997
acrylic ink on paper
$2^{1}/_{8}$ x $2^{5}/_{8}$ inches
Courtesy of Robert Miller Gallery,
New York

63 Don Nice b. 1932
American Totem Alaska II, 1986
watercolor on paper
$72^{1}/_{2}$ x 44 inches
Courtesy of Babcock Galleries, New York

64 William Nichols b. 1942
Creek at Sunset, 1998
oil on linen
50 x 78 inches
Courtesy of Tory Folliard Gallery,
Milwaukee, Wisconsin

65 George Nick b. 1927
Snow Storm, 1986
oil on canvas
20 x 30 inches
Courtesy of Howard and Beverly Zagor

66 Graham Nickson b. 1946
Study for Inlet, Dark Water, 1986
acrylic on canvas
36 x 36 inches
Courtesy of Salander-O'Reilly Galleries,
New York

67 Philip Pearlstein b. 1924
Grand Canyon—Moran Point, 1975
sepia wash
29 x $43^{1}/_{2}$ inches
Collection of William G. Pearlstein
and Miranda S. Schiller

68 Gillian Pederson-Krag b. 1938
Sunset (Grey and Orange), 1994
oil on canvas
16¾ x 18 inches
Courtesy of Hackett Freedman Gallery,
San Francisco, California

69 Fairfield Porter 1907–1975
View of Barred Islands, 1970
oil on canvas
40 x 50 inches
Rose Art Museum, Brandeis University,
Waltham, Massachusetts, Herbert W.
Plimpton Collection

70 Marjorie Portnow b. 1942
*Camino Cielo II, Santa Barbara
(Heaven's Doorway)*, n.d.
oil on Masonite
15 x 30 inches
Carolina Art Association/Gibbes Museum
of Art, Charleston, South Carolina

71 Peter Poskas b. 1939
Toward Olana, 1995
oil on canvas
29½ x 48 inches
Courtesy of Schmidt-Bingham Gallery,
New York

72 Joseph Raffael b. 1933
*In the Garden after the Rain, the Sun
Comes Out*, 1990
watercolor on paper
44 x 68 inches
The Philbrook Museum of Art, Tulsa,
Oklahoma, museum purchase in honor
of Robert Lorton for his service as
chairman of the board, 1992–1994

73 Paul Resika b. 1928
Horse Leech Pond, 1985–88
oil on canvas
38 x 50 inches
Courtesy of Salander-O'Reilly Galleries,
New York

74 Susan Shatter b. 1943
Indian Point, 1984
oil on canvas
45 x 75 inches
Courtesy of the artist

75 Bill Sullivan b. 1942
La Vida, 1997
oil on canvas
40 x 60 inches
Collection of the artist

76 Altoon Sultan b. 1948
Plastic Wrapped Bales, Barnet, Vermont,
1997
oil on canvas
32½ x 48 inches
Courtesy of Marlborough Gallery,
New York

77 Sarah Supplee 1947–1997
Blackberry Vines, 1990
oil on linen
12 x 24½ inches
Estate of Sarah Supplee, courtesy of
Tatistcheff Gallery, New York

78 Wayne Thiebaud b. 1920
Bright River, 1996
oil on canvas
23¾ X 36 inches
Courtesy of Campbell-Thiebaud Gallery,
San Francisco, California

79 Tom Uttech b. 1942
Mittogami-Mako, 1990
oil on canvas
57 x 50 inches
The Philbrook Museum of Art, Tulsa,
Oklahoma, museum purchase in honor
of Keith E. Bailey for his service as
chairman of the board, 1994–1995

80 James Valerio b. 1938
Backyard, 1993
oil on canvas
84 x 96 inches
Private collection

81 Jim Waid b. 1942
Olla, 1997
acrylic on canvas
72 x 60 inches
Private collection, Tucson, Arizona

82 Idelle Weber b. 1932
Short Thunder, 1993
oil on linen
47 x 47 inches
Courtesy of Schmidt-Bingham Gallery,
New York

83 James Weeks 1922–1998
Sonoma Landscape, 1966
acrylic on canvas
40 x 57 inches
Courtesy of Campbell-Thiebaud Gallery,
San Francisco, California

84 Neil Welliver b. 1929
Winter Stream, 1976
oil on canvas
96 x 96 inches
Smith College Museum of Art,
Northampton, Massachusetts, gift of
Mrs. Leonard S. Mudge in memory of
Polly Mudge Welliver, class of 1960

85 Jane Wilson b. 1924
Storm Light, 1993
oil on linen
24 x 24 inches
Courtesy of D. C. Moore Gallery,
New York

86 James Winn b. 1949
Clearing Off: No. 6, 1996
acrylic on paper
18½ x 46 inches
The Philbrook Museum of Art, Tulsa,
Oklahoma, museum purchase

87 Paul Wonner b. 1920
*Twenty-Seven Studies for Romantic Views
of San Francisco, No. 13, Blue and Gold
Dawn*, 1980
acrylic on paper
18 x 17 inches
Private collection

88 Andrew Wyeth b. 1917
Brambles, n.d.
watercolor on paper
21¼ x 29⅛ inches
Collection of Marylouise Tandy Cowan,
Boothbay Harbor, Maine

89 Richard Claude Ziemann b. 1932
Cricklewood Pond, 1985–86
etching and engraving
11 x 14 inches
Courtesy of the artist

Bibliography

Arthur, John. *American Realism: The Precise Image*. Tokyo: Brain Trust, Inc., 1985.

——————. *American Realism & Figurative Art: 1952–1990*, Tokyo: The Japan Association of Art Museums, and Sendai, Miyagi Museum of Art, 1991.

——————. *Realism/ Photorealism*. Tulsa: The Philbrook Museum of Art, 1980.

Boime, Albert. *The Magisterial Gaze: Manifest Destiny and American Landscape Painting c. 1830–1865*, Washington: Smithsonian Institution Press, 1991.

Conisbee, Philip, Sarah Faunce, and Jeremy Strick. *In the Light of Italy: Corot and Early Open-Air Painting*. New Haven: Yale University Press, Washington: National Gallery of Art, 1996.

De Salvo, Donna, Paul Schimmel, et al. *Hand-Painted Pop: American Art in Transition, 1955–62*. Los Angeles: Museum of Contemporary Art, New York: Rizzoli, 1992.

Farber, Linda, and William H. Gerdts. *The New Path: Ruskin and the American Pre-Raphaelites. Brooklyn*: The Brooklyn Museum, New York: Schocken Books Inc., 1985.

Gunnarsson, Torsten. *Nordic Landscape Painting in the Nineteenth Century*. New Haven: Yale University Press, 1998.

Hobhouse, Penelope, and Christopher Wood, *Painted Gardens: English Watercolors 1850–1914*. New York: Atheneum, 1988.

Jones, Caroline A., *Bay Area Figurative Art: 1950–1965*. Berkeley: University of California Press, 1990.

Moffett, Charles S., et al. *The New Painting: Impressionism 1874–1886*. Geneva: Richard Burton SA, Publishers, 1886.

Monrad, Kasper, et al. *The Golden Age of Danish Painting*. New York: Hudson Hills Press, 1993.

Newall, Christopher, and Scott Wilcox. *Victorian Landscape Watercolors*. New York: Hudson Hills Press, 1992.

Rosenblum, Robert, et al. *The Landscape in Twentieth-Century American Art: Selections from the Metropolitan Museum of Art*. New York: The American Federation of Arts, 1991.

Schama, Simon. *Landscape and Memory*. New York: Vintage Books, 1996.

Scimmel, Paul, Judith Stein, et al. *The Figurative Fifties: New York Figurative Expressionism*. Newport Beach: Newport Harbor Museum and New York: Rizzoli, 1988.

Trenton, Patricia, and William H. Gerdts. *California Light: 1900–1930*. Laguna Beach: Laguna Art Museum and San Francisco: Bedford Arts, 1990.

Vaizey, Marina. *The Artist as Photographer*. New York: Holt, Rinehart and Winston, 1982.

Varnedoe, Kirk. *Northern Light: Realism and Symbolism in Scandinavian Painting, 1880–1910*. Brooklyn: The Brooklyn Museum, 1982.

Index of Artists